This variety meant that the horse could be used for everything from personal transport to the carrying of heavy loads, and, importantly, in agriculture.

Nowadays, the relationship between man and horse has changed, especially in the developed world. The internal combustion engine was the first technical development to undermine the importance of the horse, followed by numerous other advances in mechanisation, with the result that the horse's role in industry was effectively sidelined.

In rural communities and developing countries, however, horse power is still a vital way of life, and throughout the world horses are valued for their role in leisure and sport.

This book is a celebration of the horse. From its origins in evolutionary prehistory and through the key process of domestication, we survey the domestic horse of today. The extraordinary variety of breeds found around the world is depicted and their roles as working horses or horses for pleasure are covered in depth.

To the horse lover, few scenes could be more idyllic than these two Thoroughbreds grazing peacefully in a Kentucky meadow in the first rays of morning sunshine. The breed stands 16 hands high and is a popular racing horse.

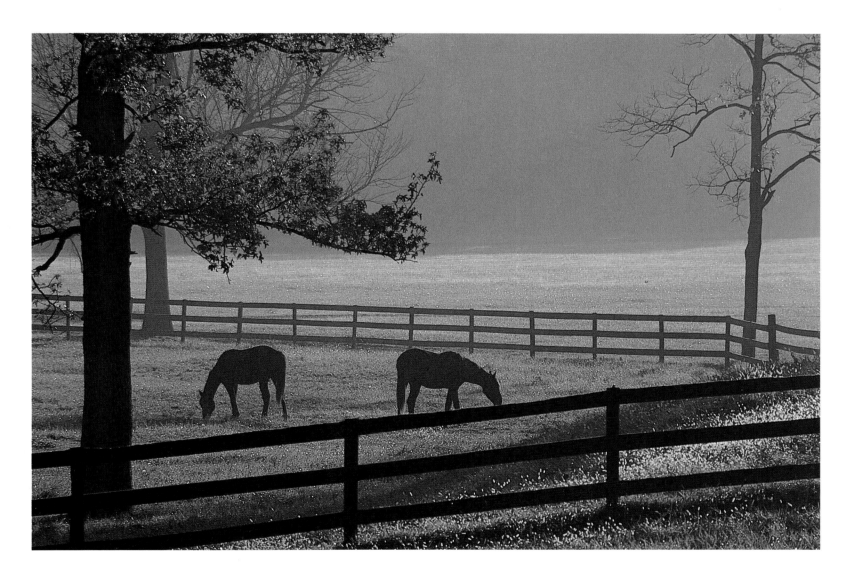

Descended from horses belonging to the Spanish conquistadors, these wild Mustangs run free in Nevada. They were used by Native Americans and later by European settlers for cattle ranching.

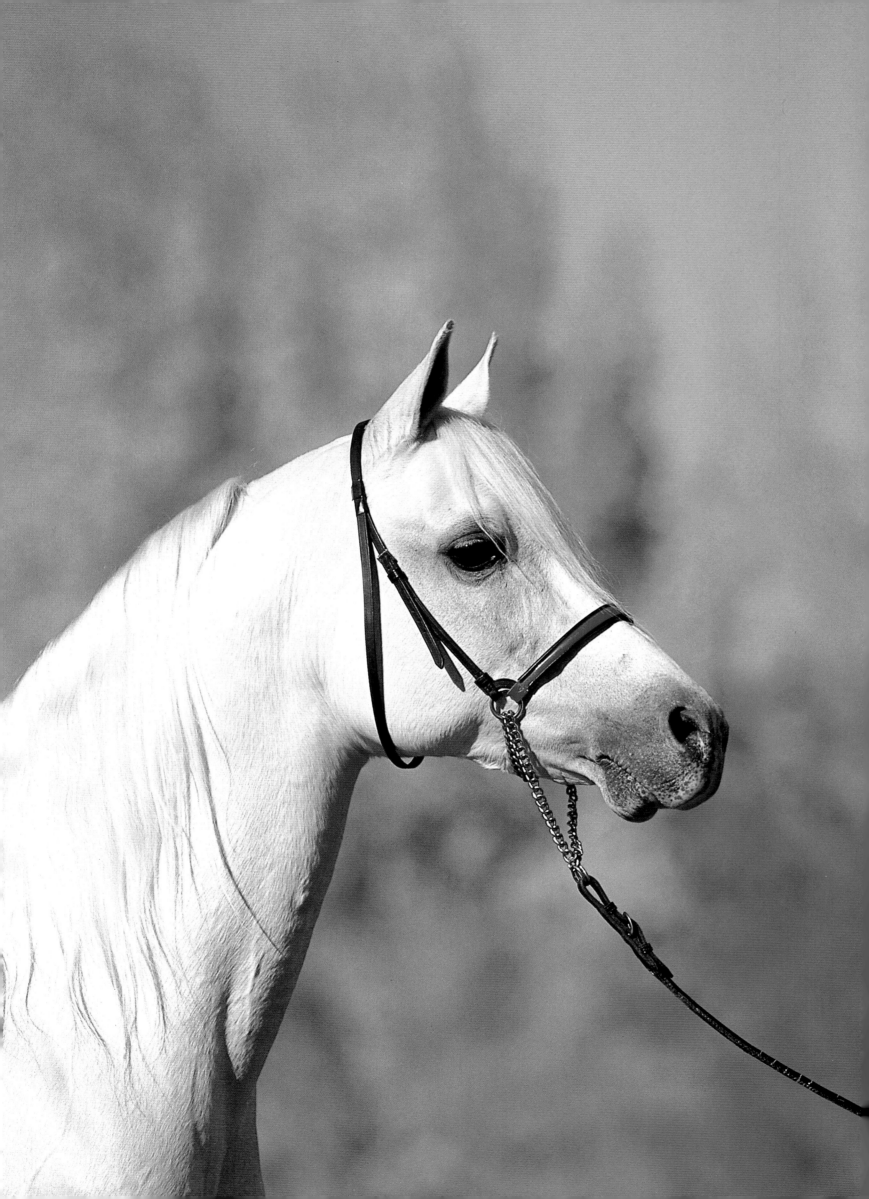

HORSES IN PERSPECTIVE

The Evolution of Horses

The relationship between man and horse can be traced back several thousand years, during which time the physical appearance of horses has changed dramatically. The true origins of the horse, however, date back much further, with changes taking place over millions of years rather than centuries. Thanks to fossil records and the dedication of skilled palaeontologists, we have a clear picture of the process.

Over millennia, clear evolutionary trends in horse development can be observed; changes which resulted in the fast-running, grazing animals we see today. Distant ancestors had five digits in each foot; gradually, these evolved into hooves. At the same time, the limbs became more and more elongated; both these adaptations and the development of the hoof would have served to enhance the ability to run at speed on tiptoe. Other changes in ancestral horse anatomy include a gradual trend toward increase in size, while the structure of the teeth and jaw and the depth of the skull in profile were all modified to suit a grazing lifestyle.

The first horse-like ancestor, Hyracotherium—popularly known as Eohippus or 'dawn horse'—appeared about 55 million years ago and browsed vegetation in prehistoric forests. It had four digits in its front legs, three in the rear legs, and was the size of a

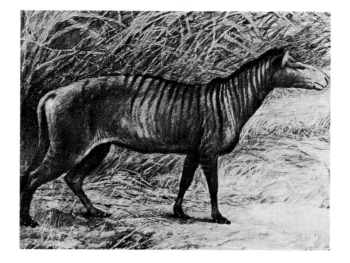

Horses evolved from animals with four front and three rear toes to the modern horse, which runs on a single digit. This illustration shows a three-toed Hipparion—a horse ancestor that flourished roughly ten million years ago.

small dog. Fossil records of Hyracotherium have been found both in North America and in Europe.

Three-toed horses first appeared about 35 million years ago. The increase in species diversity corresponded to the appearance of the first grasses and adaptations for grazing. It was not until 15 million years ago, however, that the first one-toed horses appeared, Hippidion being the best known example. From this ancestor, the genus *Equus*, in which the domestic horse and its few surviving relatives are classified, evolved. The range of species contained in this genus has declined dramatically over the last two million years. In fact, the rate of extinction

Following page: True members of the horse family, Grevy's zebras live wild in arid savannah regions of East Africa in small herds of ten to fifteen animals. They are distinguished from the common zebra by their white belly and narrower stripes.

Often considered the most noble of horse breeds, the Arab has an air of distinction. The breed stands 14.3 hands high and a grey coat is favoured.

Many populations of common zebras in East Africa undergo long seasonal migrations, following the rains in search of fresh pastures. These animals cross the Mara River in Kenya on their way south to Tanzania's Serengeti Plain.

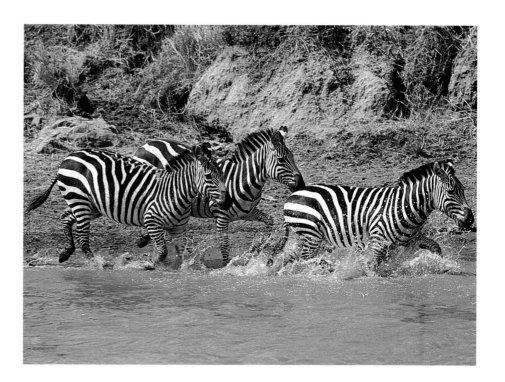

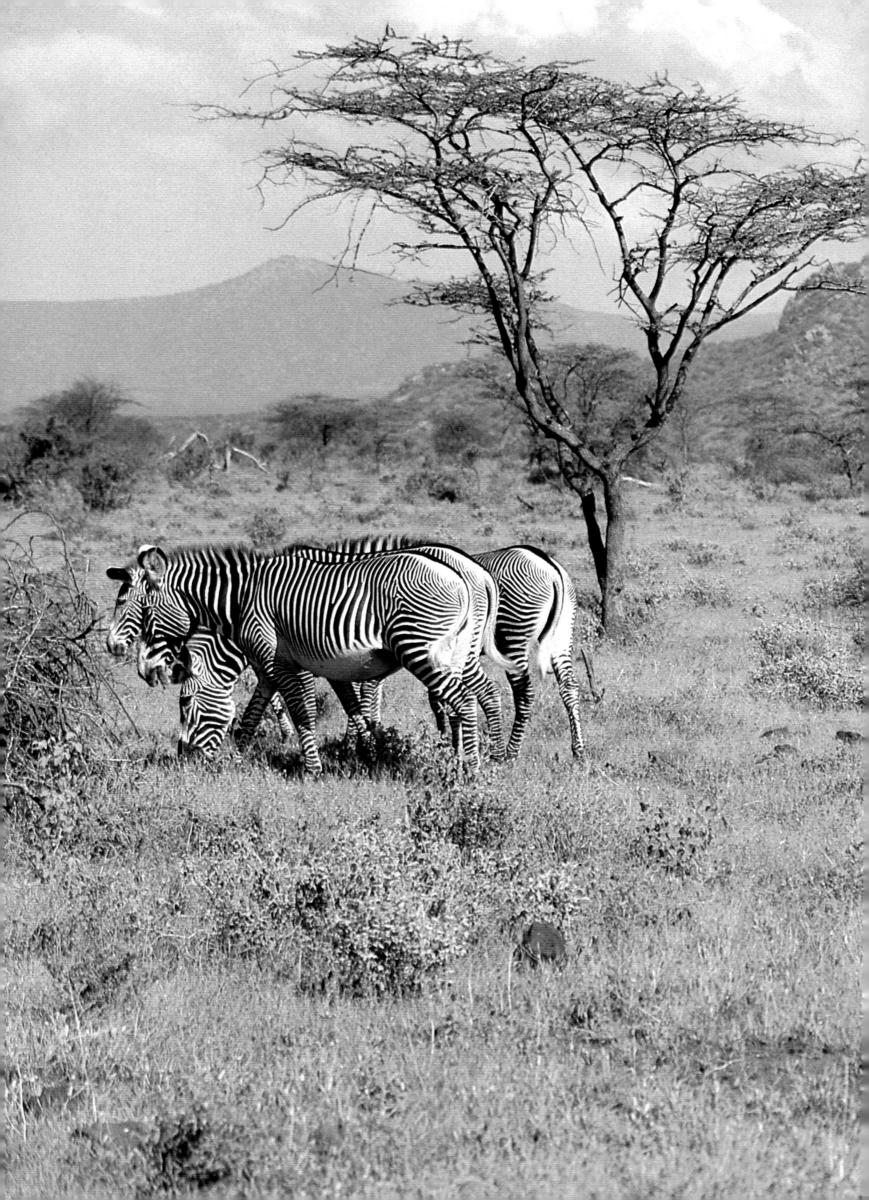

was nothing short of catastrophic. It is a particular irony that North America, a region where horse evolution had flourished for millions of years, saw the complete extinction of horses during this period. Were it not for their reintroduction by the Spanish conquistadors, this would still be the case.

A Survey of the Horse Family

Despite its diverse ancestry, the horse family only numbers seven living species today. The best known of these—the domestic horse—comes in an array of breeds, shapes, and sizes. Horses are found in all parts of the world. Although feral populations do exist, the geographical range of this species is entirely influenced by man. The remaining six species all occur in the wild. These are the zebras of Africa, the asses of Africa and Asia, and Przewalski's horse, a wild species and the closest living relative of the domestic horse.

All members of the horse family have characters in common: they are all adapted to a herbivorous diet and are anatomically suited to running at speed. The legs are long and the weight of the body is supported by the single, hoofed middle toe on each foot. The neck is long and the head itself is rather elongated. Grass and vegetation are bitten off using the upper and lower incisor teeth, while sturdy molar teeth grind the plant matter for swallowing.

Although in the past controversy has raged about the classification of zebras, there are now considered to be three distinct species in Africa. Their distribution ranges throughout East Africa from the southern tip of the continent northward to Ethiopia. The most widespread species, the plains or Burchell's zebra (*Equus burchelli*) is found on grassland and savannah, often in large herds. It is characterised by broad stripes, although

Przewalski's horses are thought to have been the ancestors of the domestic horse, first domesticated several thousand years ago. Also known as the Mongolian wild horse, a few herds still live on the edge of the Gobi Desert in Asia.

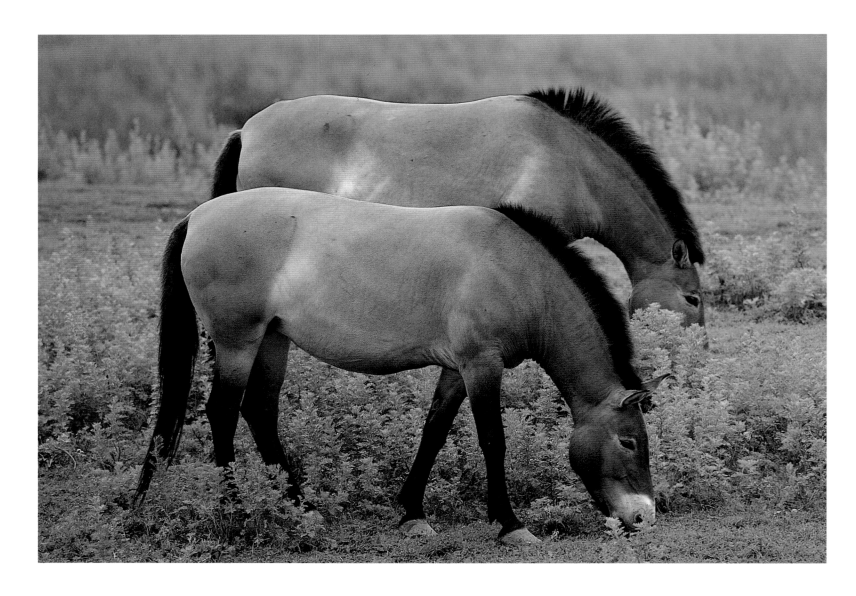

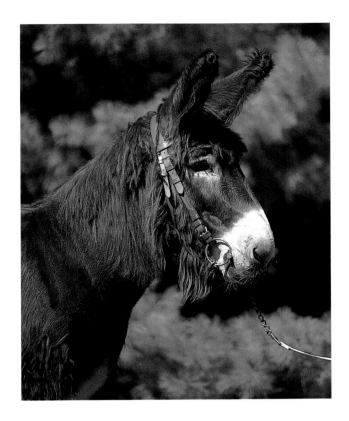

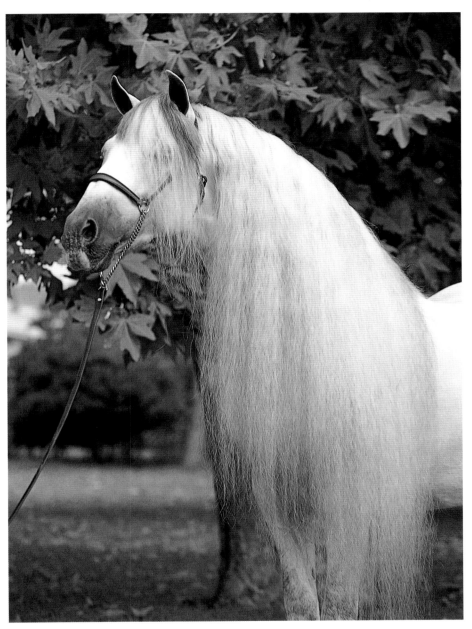

Descended from the domesticated ancestors of wild asses, donkeys are used as pack animals in many parts of the world. They are also popular in some circles as show animals.

considerable variation occurs. Grevy's zebra (*Equus grevyi*) is confined to arid grassland regions in northern Kenya, Somalia, and Ethiopia. It has narrower stripes and a more mule-like appearance than its cousin. The last species, the mountain zebra (*Equus zebra*), occurs in the uplands of southern Africa. It is slimmer than the plains zebra and has a dewlap on its throat.

There are two species of asses, one found in Africa and the other in Asia. Both are desert species, superbly adapted to life in arid environments. The African ass (*Equus africanus*) occurs in Sudan and Ethiopia while the Asiatic ass (*Equus heminus*) can be found locally from northern India to Syria. Asses live in small herds and follow a mostly nomadic lifestyle. In some areas, they are under threat from competition with domesticated livestock.

The remaining species is called Przewalski's horse (*Equus przewalski*), sometimes known as the Mongolian wild horse. It lives in the Altai Mountains of Mongolia, on the edge of the Gobi Desert, and was once under threat of extinction. Przewalski's horse is considered the ancestor from which the domestic horse (*Equus caballus*) is descended. A close relative of Przewalski's horse, the tarpan, lived wild in Europe until the end of the nineteenth century. Considered by many to have been simply a race of Przewalski's horse, tarpan-like horses have recently been recreated by cross-breeding ancient breeds and their wild ancestors.

The Origins of Domestication

Prehistoric cave paintings give a clear idea of man's first relationship with the horse: hunting scenes indicate it was a primary source of food. Increasing levels of sophistication

As its name suggests, the Andalusian comes from the region of the same name in southern Spain. It is a popular schooling horse. A considerable amount of daily effort is required to keep a mane of this length in good order.

The Tennessee Walking horse is a comparatively recently recognised breed. It comes from the southern American state of the same name and has a smooth, exaggerated gait, somewhat unnatural in a horse of this stature.

in human societies were accompanied by the domestication of a wide range of animals. Never slow to explore new opportunities, man soon turned his talent for domestication on the horse.

Scientists now believe that domestication of the horse probably occurred in central Asia roughly five thousand years ago. Three millennia later, the practise had spread across the continent, with horses used for all purposes, from battle mounts to beasts of burden. The horse had become an integral part of human society and was to accompany man's progress through the ages until the industrial revolution dawned on the western world.

The first people to attempt to domesticate the wild horse probably lived semi-nomadic lives on the vast steppes of Asia. Here, horses were captured from the wild and bred in captivity. They were ridden to drive herds of cattle and also pulled carts and transported heavy loads. It was perhaps from these origins that the horse's involvement in war and battle developed. Even without the aid of stirrups and saddles, skilled archers and swordsmen evoked fear in the hearts of their oppo-

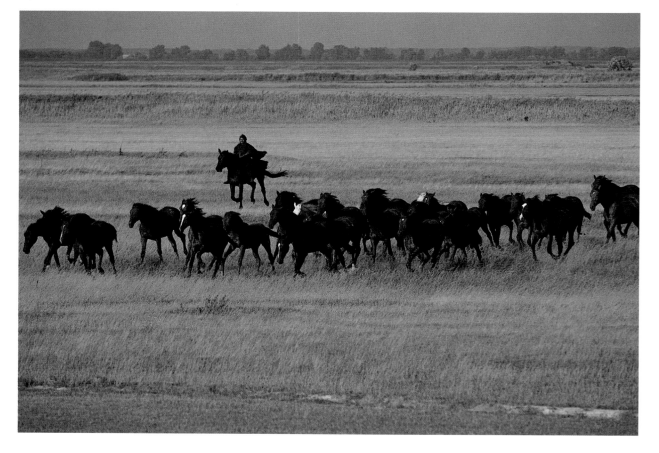

Developed in Hungary from English Halfbred, Arab, and Thoroughbred stock, the Furioso, as its name implies, is a lively warmblood. It stands roughly 16 hands high and has a powerful build.

A few traditional farms in England still use Shire horses instead of tractors to pull their ploughs. In certain situations, these magnificent animals can work land that is inaccessible to their mechanical successors.

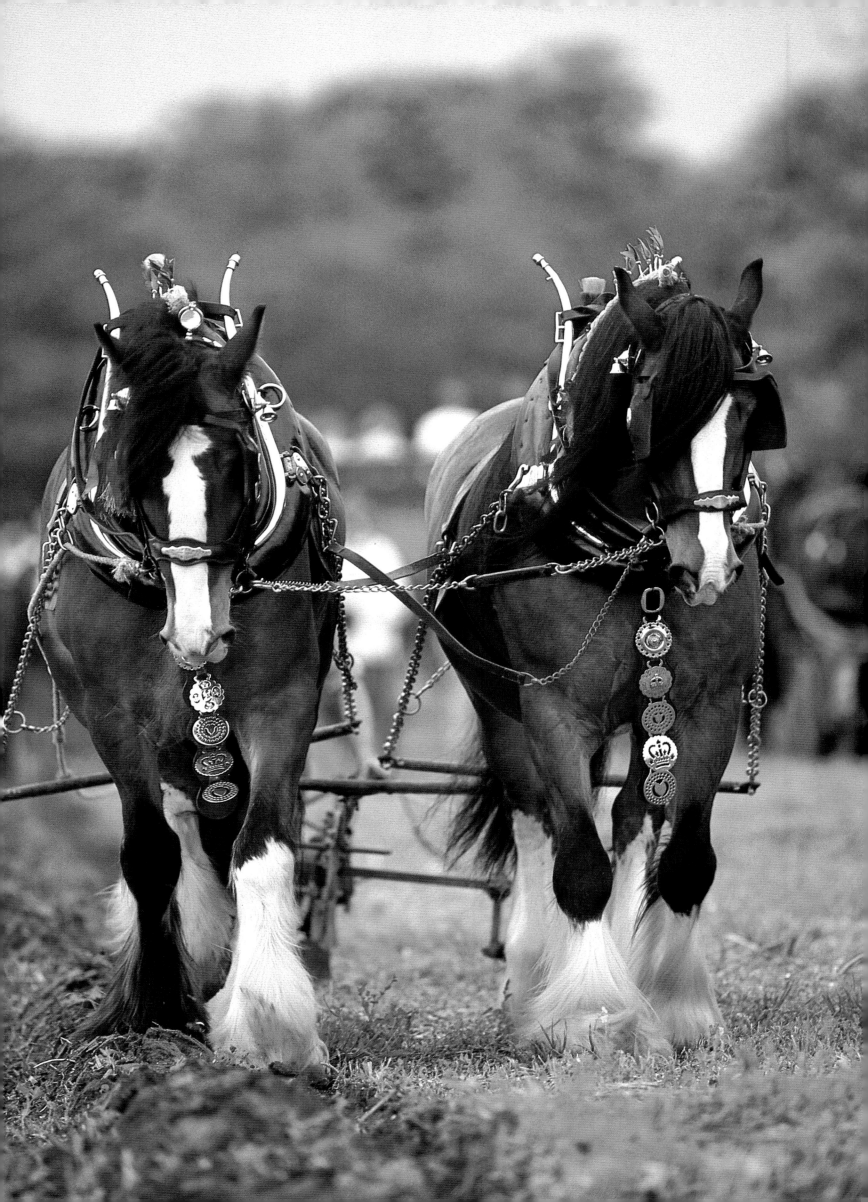

A thick winter coat makes sure that most hardy horses can survive even the worst winter weather. These are taking advantage of some winter sunshine; at night they will find a sheltered spot and huddle together for warmth.

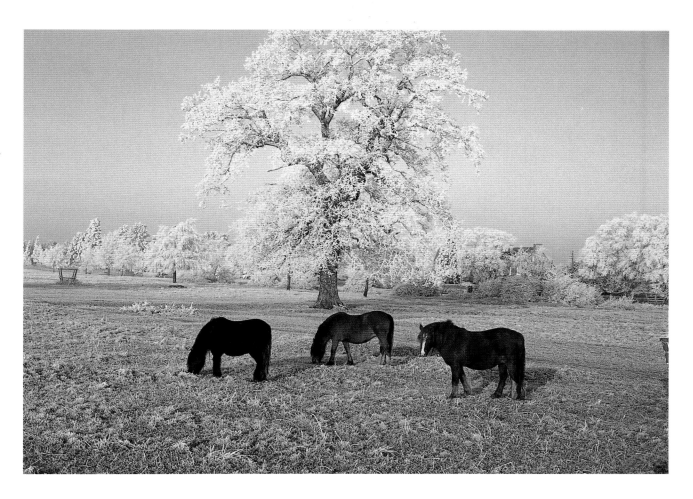

The Dutch Heavy Draught horse shows all the characteristics most sought after in a working horse: it has a powerful build, superb stamina, and a mild temper even when worked to its limits.

The Trakehner originally came from East Prussia. The line was all but lost in its native region during World War II. It does, however, persist as a breed in Europe and North America.

nents. Horse-drawn chariots were another favoured use.

Early domesticated horses differed little from their ancestral stock in terms of appearance, size, and stamina. But three thousand years ago, a range of breeds had begun to appear among horse-conscious societies in eastern Asia. There were breeds of horses specifically created for speed, size, power, or endurance. All subsequent empires, whether Chinese, Persian, Greek, Roman, or modern European, were bolstered by their dependence on the horse. Almost all major battles and wars, up to and including World War I, relied heavily on horses. Their casualties were proportionately as great as those of the servicemen they accompanied. Although superceded by advanced machinery, the role of the horse in war has not been forgotten and cavalry regiments still parade proudly on horseback.

Although used in Asia for a wide variety of

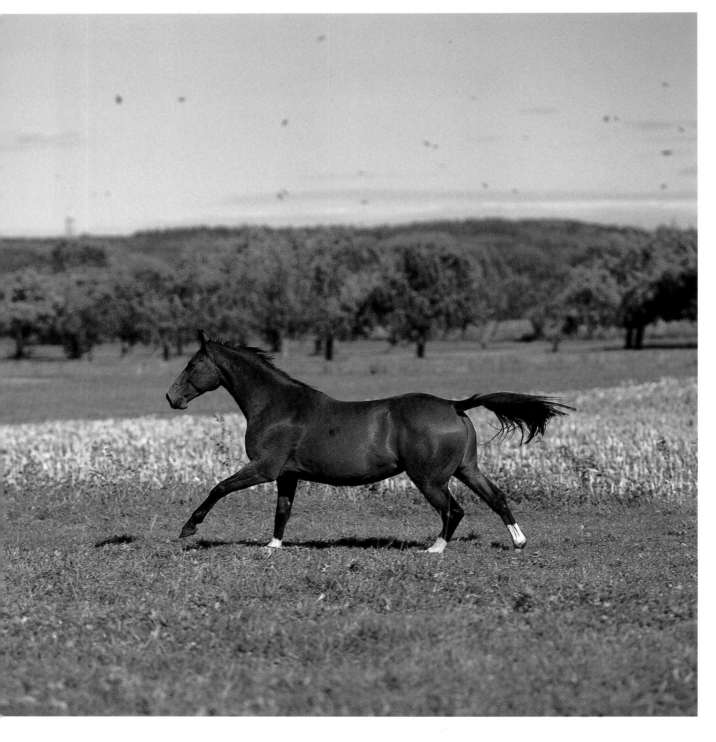

The Holstein is a popular breed both in its native Germany and around the world. It was developed in Schleswig-Holstein from Marsh Horse stock, ideally adapted to the wet, marshy terrain of the region.

It is generally accepted that the Thoroughbred, developed in Britain and Ireland, is the definitive racing horse. It is capable of the fastest speeds and its bloodstock has influenced almost all other breeds developed for the sport.

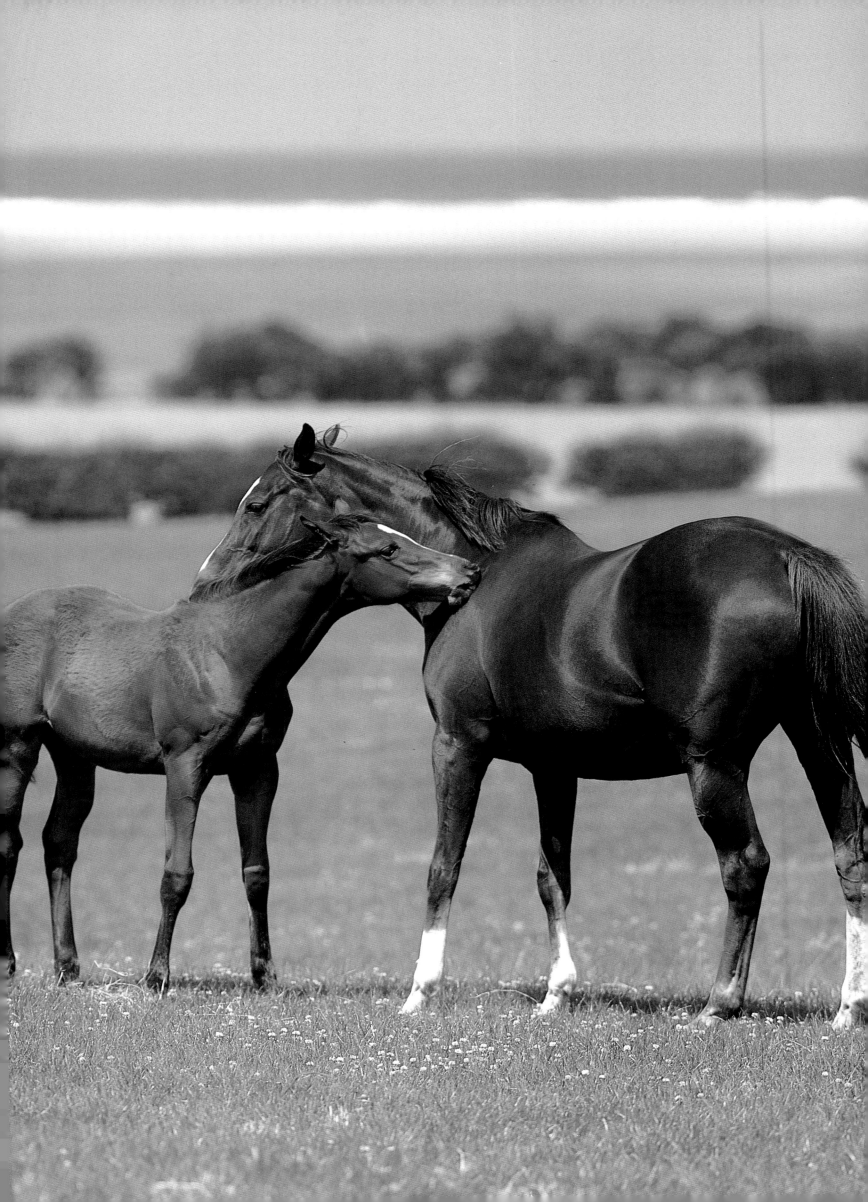

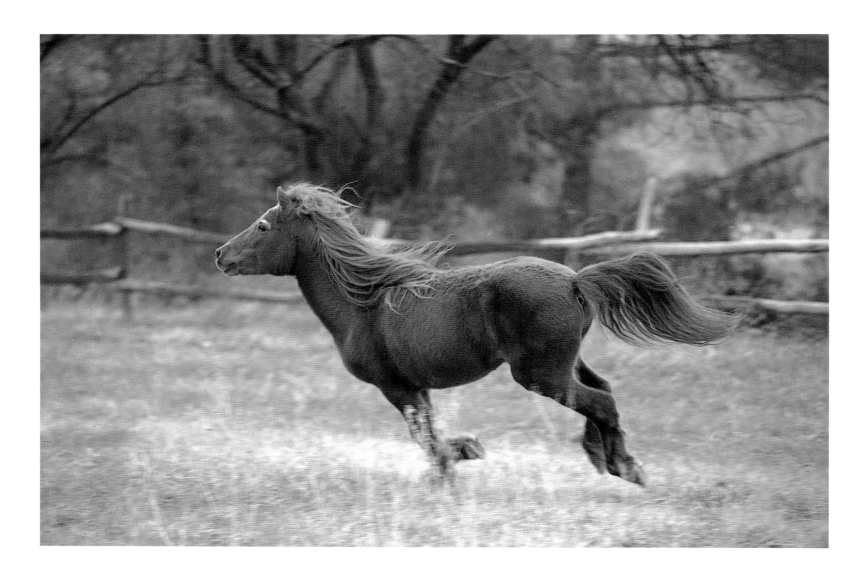

A dashing view of a Skyros pony, originally developed on the Greek island of that name. It was and still is used for all manner of work including ploughing and carrying heavy loads.

farming practises, horses played only a small role in the agriculture of western Europe until the seventeenth century. Breeds of heavy horses and improved harnessing enabled horses to compete with oxen for the unenviable role of chief beast of burden. The heyday of the horse in European farming began in the early eighteenth century. Revolutions in agriculture practises and machinery saw horses become vital to rural life, a far cry from their former position as animals of the aristocracy.

Horses were important too, of course, as means of personal and public transport and in the transport of heavy loads. At the start of the industrial revolution, their importance, if anything, increased for a short while. In some cases, it was more efficient to use horses to power machines. Pit ponies were invaluable in mines, and horse-drawn barges plied the canal network, transporting goods and raw materials to and from the hearts of industry and commerce.

By the late nineteenth century, however, the use of horses had largely been sidelined by mechanisation in Europe. However, the story of the horse in North America was different. Extinct in the wild since before the last Ice Age, horses were reintroduced by the Spanish conquistadors. Feral populations soon developed and native Indians were quick to tame them for their own needs. At the same time, the Americas were colonised by other Europeans who brought with them their own supply of horses. Without doubt, the horse played a pivotal part in taming the 'Wild West': horse-drawn wagon trains brought settlers across the continent and ranching cattle would have been impossible without them.

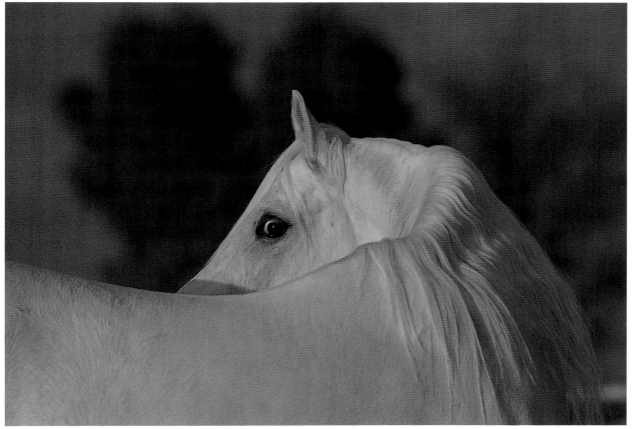

Wild white ponies are a feature of the Camargue, an area of marshes in the south of France. They are used by local people for rounding up livestock, including the famous black bulls that roam freely over the wetlands.

There are few breeds of horse recognised today that do not have at least some Arab blood in their ancestry. This is not surprising since these alert animals have great stamina, which enriches any bloodline.

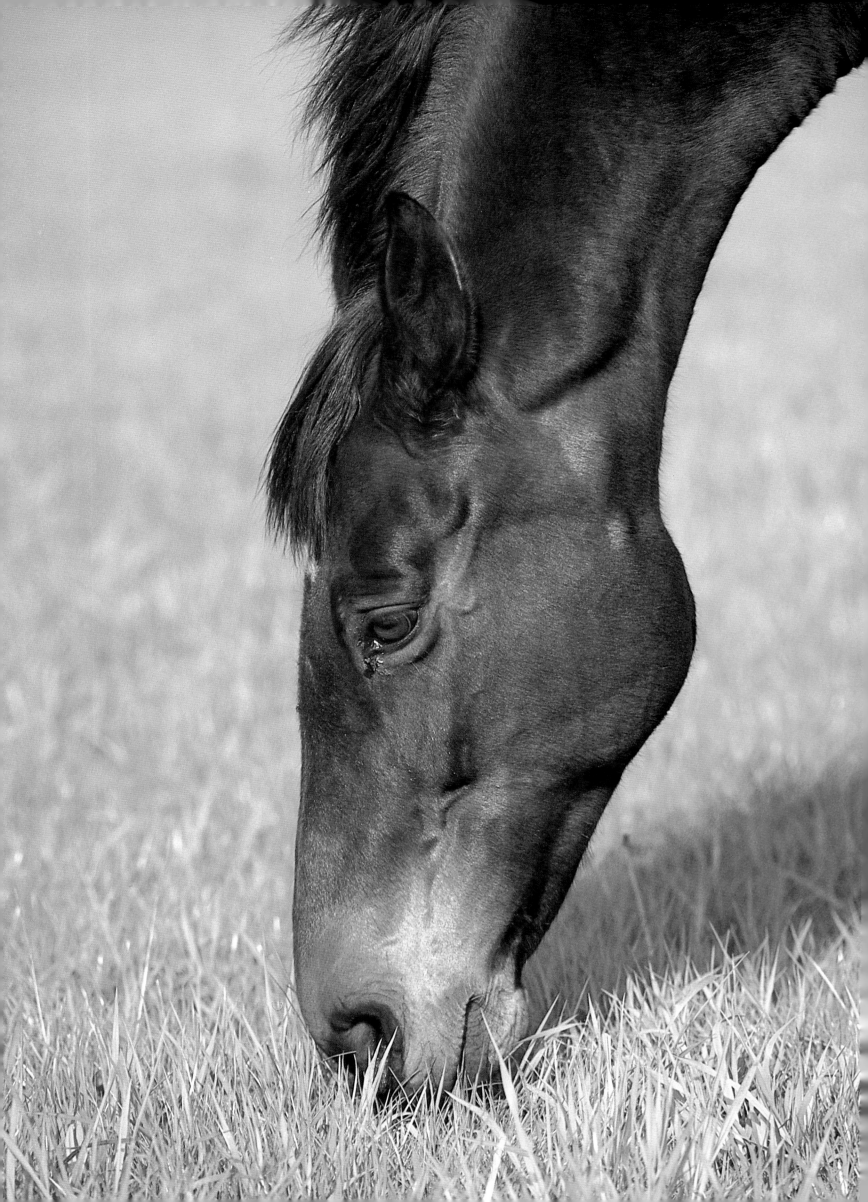

THE DOMESTIC HORSE

Grazing

Through the millennia, the horse evolved from primitive ancestors that browsed foliage into an efficient grazing animal. The teeth, mouth, and digestive system are adapted to almost constant feeding, a lifestyle ideally suited to the close-cropped, grassy plains where wild horses originated.

An adult horse has forty teeth, arranged to make the collection and processing of grass most efficient. At the front of the mouth are six incisor teeth in both the top and bottom jaws. These have sharp, shearing edges which oppose each other and cut the vegetation. To compensate for wear and tear, these teeth continue to grow throughout the life of the horse. The highly mobile lips assist the grass-cutting action of the incisor teeth by grasping clumps of grass and holding them in position for cutting.

On both sides of the upper and lower jaws, there are six grinding teeth, three premolars,

First established as a recognised breed in 1948 from a well-pedigreed local breed with Arab blood, the Tersky is now widespread in parts of Russia and the eastern Slavic states. These were photographed in the Caucasus mountains.

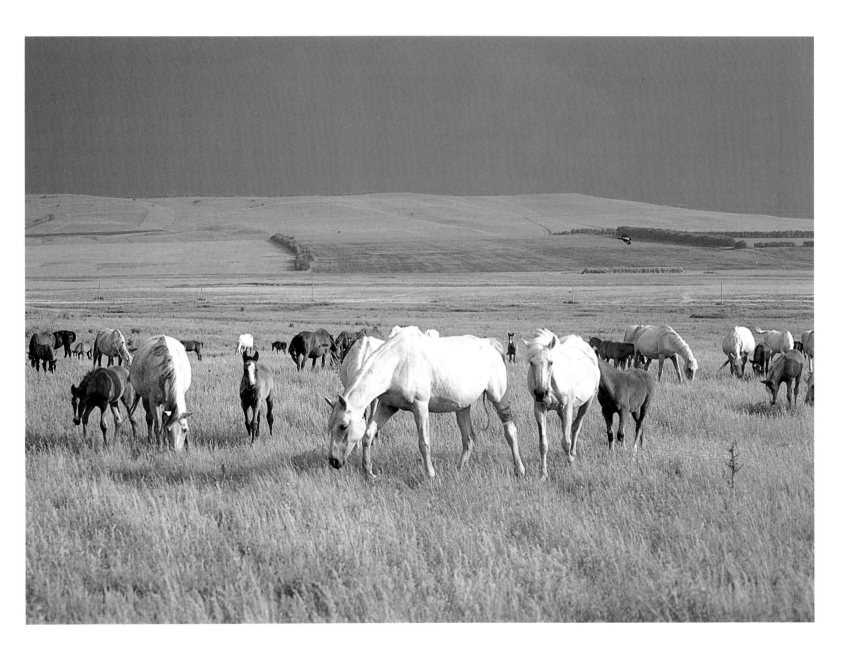

Horses have evolved both for speed and for a grazing lifestyle. This Thoroughbred has a long neck for reaching the grass and shearing incisor teeth. The flexible lips assist in grabbing herbage for consumption.

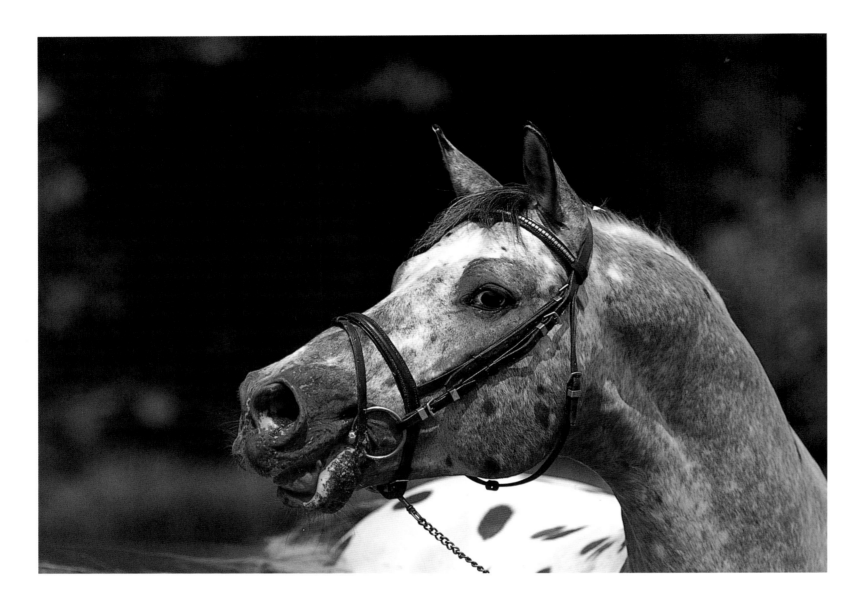

Over countless millennia, evolutionary forces have acted to refine the head of the horse for a grazing lifestyle. Seen in profile, the head of this Knabstrub clearly shows the elongated jaw and prominent muscles necessary to power the grinding motion of the jaws and teeth.

and three molars. These also grow continuously to compensate for wear and tear and have flat surfaces bearing sharp ridges. When rubbed over one another, these ridges serve to cut and grind the grass prior to swallowing. The full complement of teeth is made up by four canine teeth, one on each side of both upper and lower jaws. These are present only in geldings and colts.

Structure and wear in the teeth can be used to age a horse. Until the age of five, temporary incisors are present. For the next three years, wear on the cutting edges and sides of the incisors provides accurate aging. Thereafter, a combination of wear patterns and the angle of the teeth are used.

Like the teeth, the digestive system of a horse is designed for processing a continuous supply of plant material, specifically grasses. Compared to that other well-known herbivore, the cow, the stomach of a horse is comparatively small, whereas the large intestine is relatively large. This is because the digestion of plant fibre is carried out by bacterial action in the intestine rather than the stomach. An ignorance of the way horses feed—eating small quantities of food but almost continuously—can lead to problems in stabling. If horses are allowed access to large volumes of hay they will often gorge themselves; this can sometimes literally block the digestive system, with drastic consequences.

A Kabardin horse from the northern Caucasus. In its native terrain, this breed can build up reserves of fat in flower-rich meadows during the summer but has to contend with harsh winters and frozen ground for several months of the year.

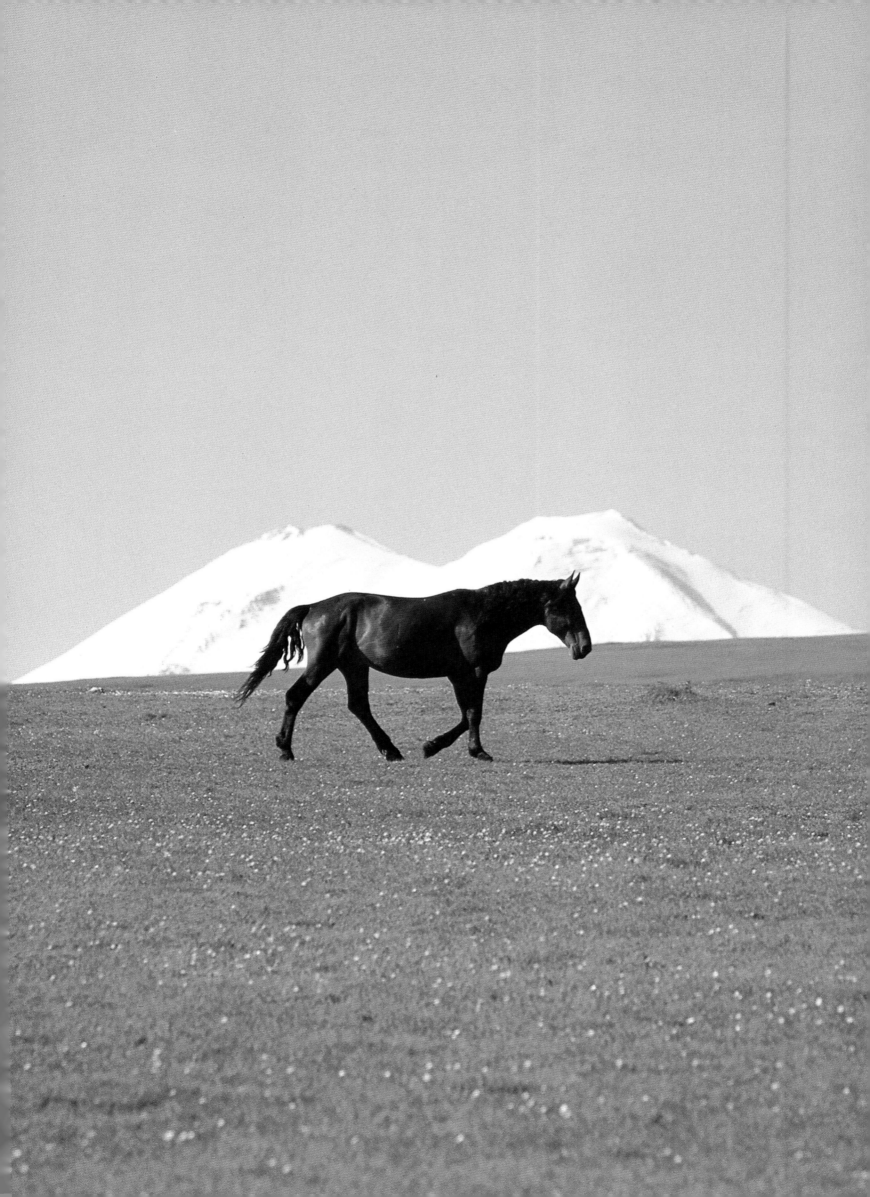

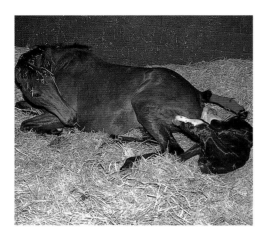

A newborn foal takes its first look at its mother. Although owners are usually encouraged to keep a discreet eye on a foaling mare, she is generally best left in solitude unless there are complications with the birth.

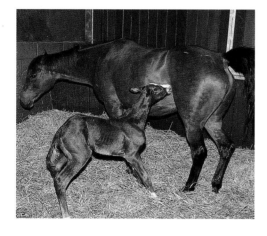

The first steps of a young foal are usually rather jittery and unsteady. However, within a few days it will have become confident on its feet and will be almost able to keep up with its mother's pace.

A Welsh Pony mare and foal enjoying a gallop through a buttercup-filled meadow. Although standing under 13.2 hands high, this is a robust breed and ideal for trekking and driving.

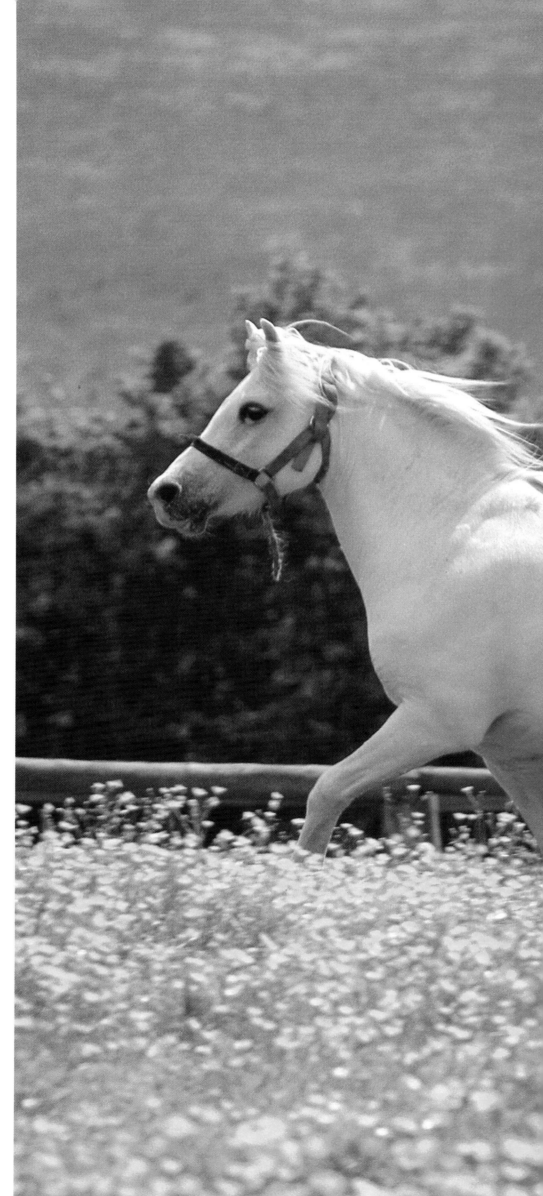

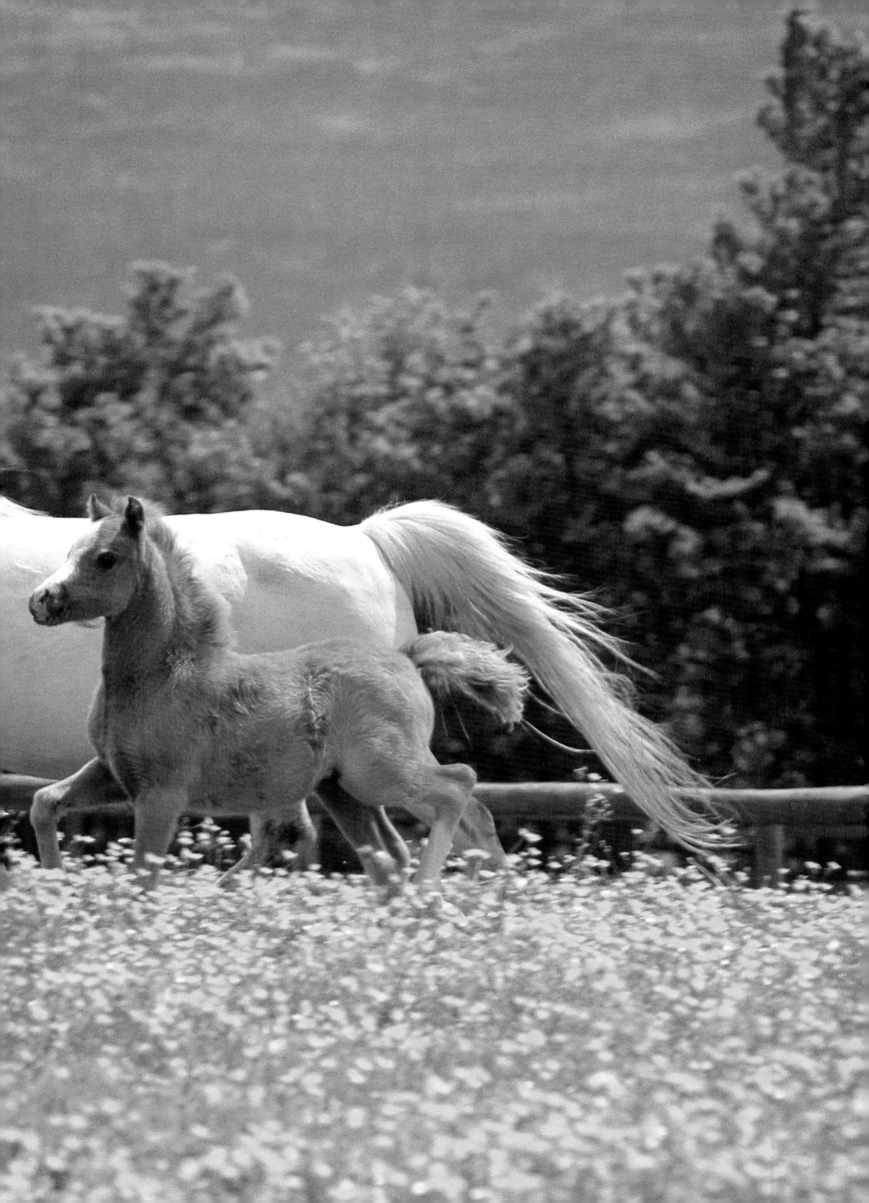

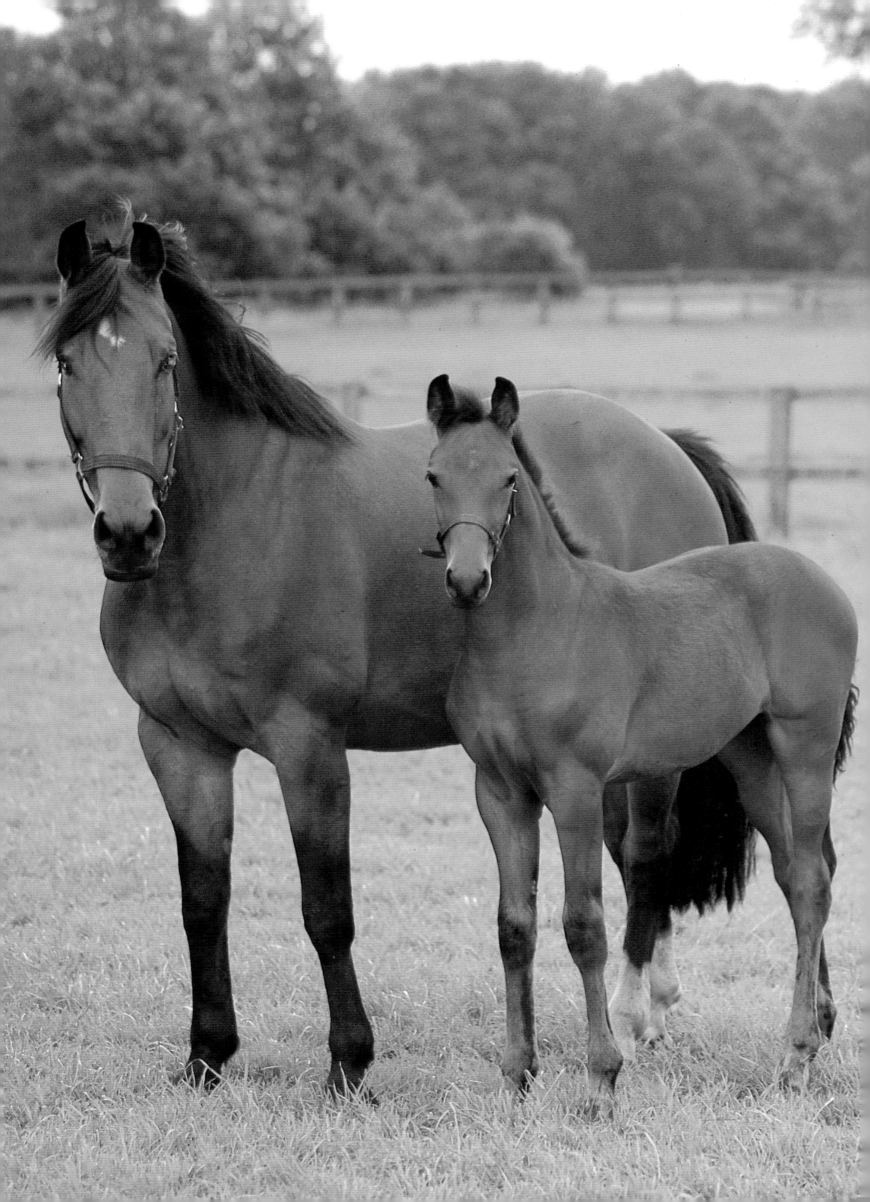

Breeding

Although selective breeding over several millennia may have radically altered the outward appearance of the domestic horse, the basic reproductive biology remains the same. Horses, like other Equids, give birth to a single foal on most occasions, and a pregnancy lasts for roughly 333 days. During this period, in common with all other placental mammals, the developing foal is nourished in the mother's womb through a complex network of arteries and veins.

The mare gives birth lying down and, under normal circumstances, the head and forelegs are presented first. Complications in birth are not uncommon, but most can be sorted out easily by a veterinarian or someone with experience. After a few days the foal is able to walk properly and soon gains strength. For the next few months, it feeds on its mother's milk and gradually takes to grazing. Left to its own devices, the mother would eventually reject the foal's attempts to suckle given enough time. Under domestication, however, the foal is normally separated from its mother after six months or so and thus forcibly weaned.

There can be few more endearing sights to the horse lover than a young foal. This young Welsh Pony is developing confidence, temporarily away from the care of its mother.

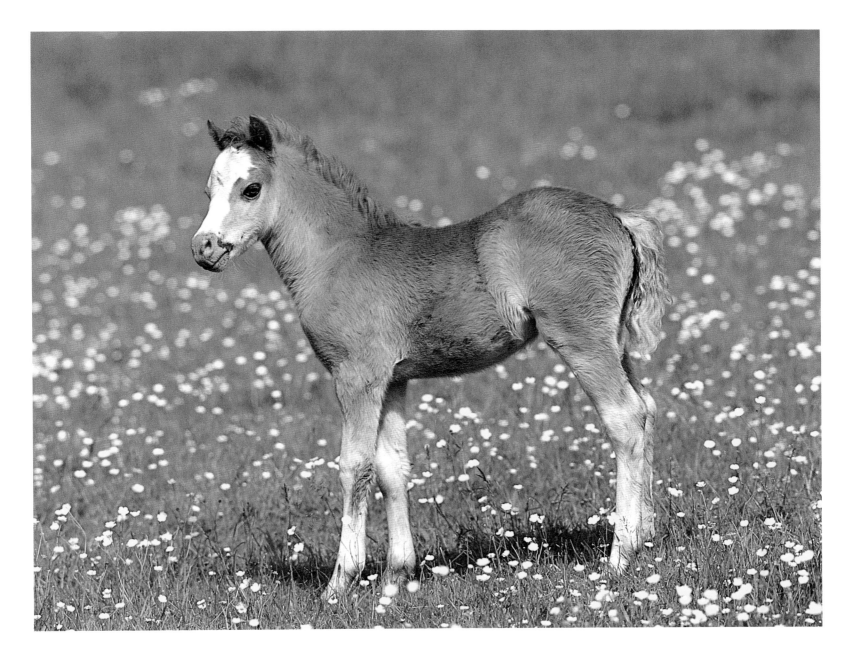

A Danish warmblood mare and foal. Foals are usually born in early spring and are best left with their mothers throughout the spring and summer months. Weaning usually takes place in the autumn.

Movement

Horses evolved as herd animals with alert senses and the ability to run fast to escape from predators. This adaptation for survival is perhaps what first attracted man to the horse and selective breeding has often accentuated both the leg length and the speed of the animal. Essential for this speed are four long, powerfully-muscled legs, with the body weight supported on the hoofed central toe of each leg.

As in other mammals, the legs of a horse are supported by bones. The separate bones within the leg are articulated at joints which provide the mobility necessary for movement. At the joints, the bones are coated with a rubbery material called cartilage and the joint as a whole is enclosed in a membrane containing lubricating synovial fluid. Tough, fibrous ligaments support the joints and movement of the legs is carried out by muscles attached to the bones.

Arguably, the most important bones in the leg are those of the foot. In order to gain protection and support and to increase the surface area that comes into contact with the ground, the foot is encased in a horny hoof made of a substance called keratin—the same substance from which human fingernails are made.

Horses' hooves vary tremendously in size and surface area from breed to breed. Heavy working horses such as Shires have huge, broad hooves whereas an Arab horse has

A Danish warmblood gallops freely. 'Warmblood' is a general term applied to breeds that are high-spirited and active; 'coldblood', on the other hand, refers to more placid and quiet breeds.

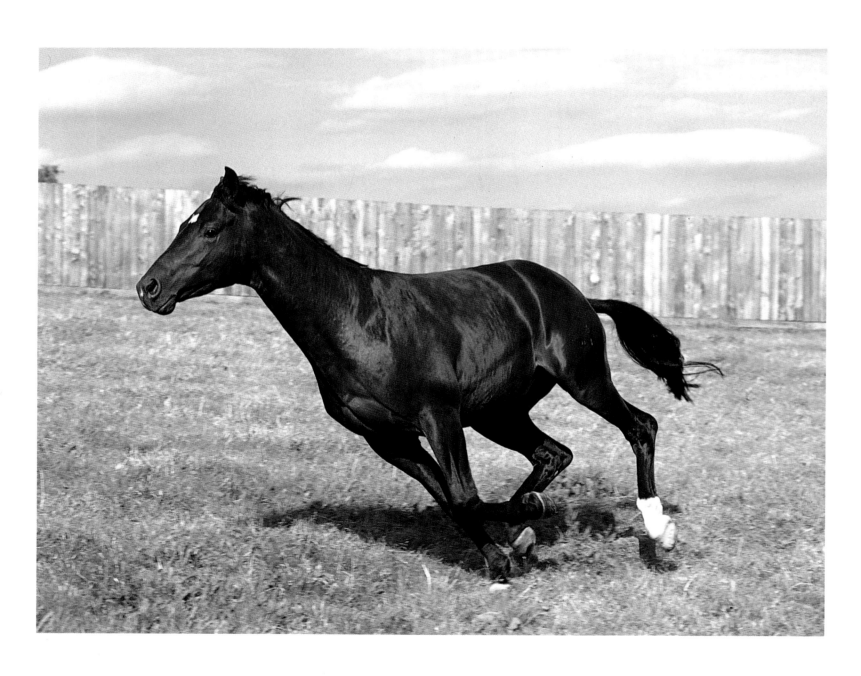

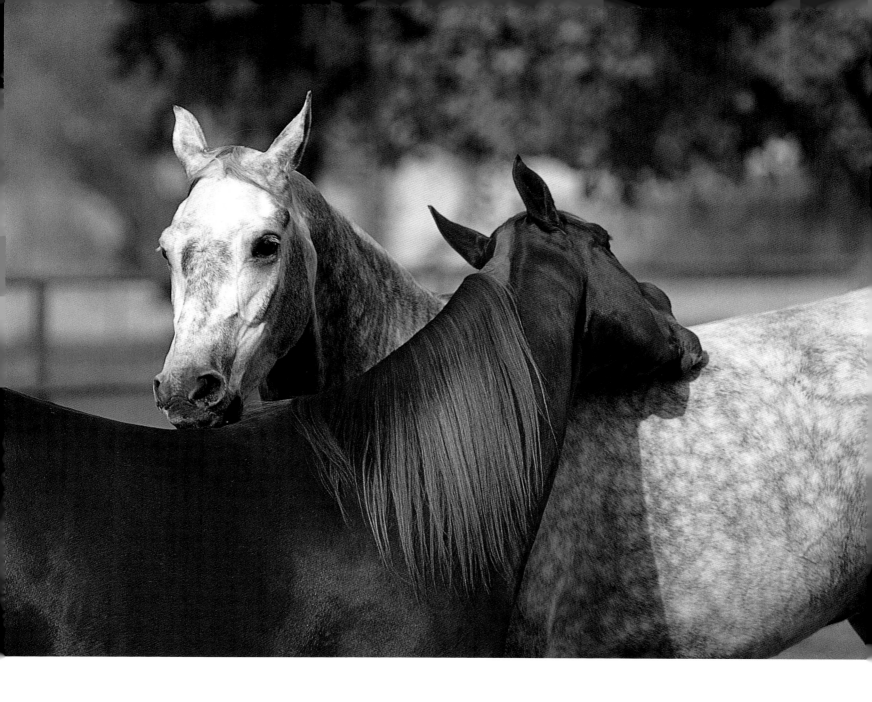

relatively slender hooves. One thing that they all have in common, however, is that the hooves are continually growing. This natural process has evolved to compensate for wear and tear as the horse runs. Under many circumstances, however, the domestic horse walks and runs on unnaturally hard surfaces such as paved roads and gravel paths. To avoid the problem of the hoof wearing down faster than it can grow, the foot is usually shod.

Movement in the horse can be divided into four distinct categories: walking, trotting, cantering, and galloping. As you might imagine, walking is the slowest pace adopted by a horse. The legs are moved one at a time in a recognised sequence: left foreleg/right hindleg/right foreleg/left hindleg. Despite the apparent simplicity of this movement, walking still involves the coordination of thousands of different muscle groups.

Trotting is slightly faster than walking. In this type of movement there is a very brief moment when all four legs are off the ground and the legs move in diagonal pairs. As the horse runs faster, the rhythm of movement must change for added efficiency. The next stage is cantering, during which long strides are used with one or the other of the forelegs leading. A typical sequence would be right foreleg/right hindleg and left foreleg together/right foreleg. This sequence is followed by a brief moment when all four legs are off the ground, the period being longer than that in trotting.

Galloping is observed when the horse is moving at full speed. The period during which all four legs are off the ground is much longer than in either trotting or cantering. A sequence of movements would be left hindleg/right hindleg/left foreleg/right foreleg.

Mutual grooming is an important part of life for horses, including these Arabs. Horses are not solitary animals and do best when kept in the company of others.

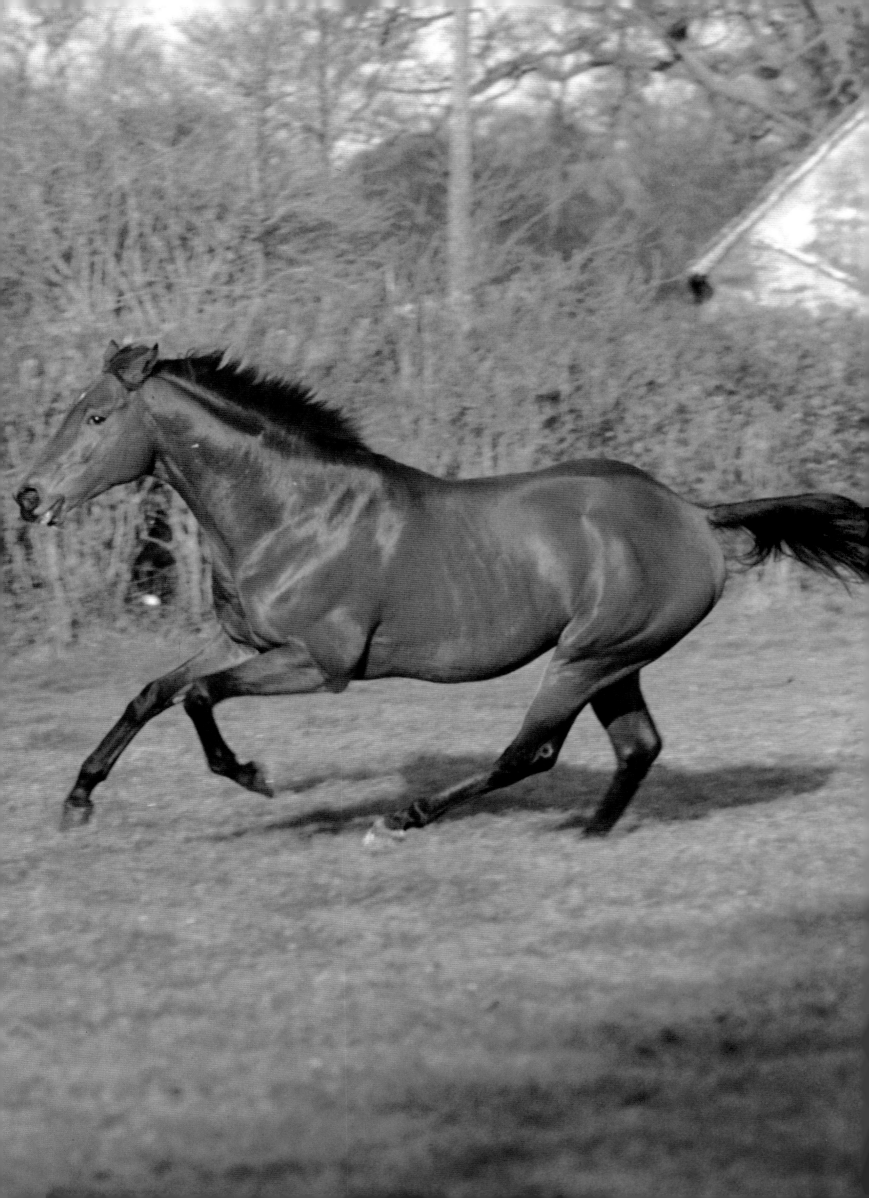

Terminology

Horses vary tremendously in terms of size, colouration, and markings. Although members of a particular breed are usually of standard height and background colour, the markings on the head and feet may vary considerably, enough that by using a combination of features a unique description of each horse can be created.

The height of a horse is measured from the ground to the highest point of the shoulders, known as the withers. The conventional means of expressing the measurement in the United Kingdom, Ireland, Australia, and North America is a 'hand', this being four inches (10.25 centimetres). The height of a horse or pony is often written as 'hh', an abbreviation of 'hands high'. There are also smaller subdivisions: a measurement, for example, of 12.3 hands would refer to a height of 12 hands and 3 inches. 12.2 would mean 12 hands and 2 inches and 12.1 would mean 12 hands and 1 inch.

The background colour of a horse can vary considerably. Typically, this might be a shade of chestnut, cream, dun, black, or white. The colour might be uniform across the body or it can be a mixture of several hues. Most horses have white markings on their head and feet. These markings have well-established names: a narrow band of white down the forehead is referred to as a 'stripe', while a broader stripe

A group of Swedish warmbloods looks on as one of their number enjoys a good dust bath. This behaviour is clearly pleasurable for the horse and helps to clean the coat and remove any external parasites.

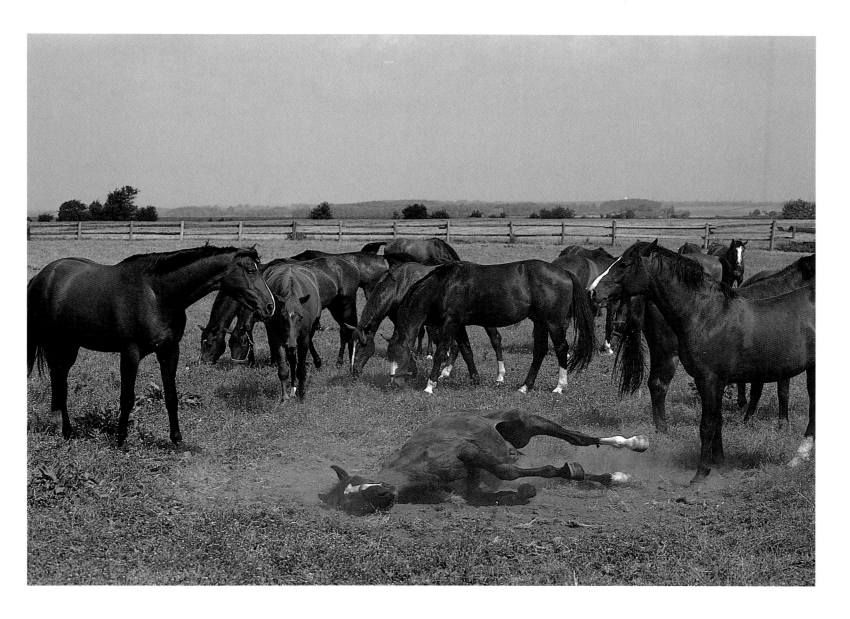

The gallop is the horse's fastest pace. While running in this mode, there is a long moment when all four feet are off the ground at the same time. This Thoroughbred has been bred for stamina and speed.

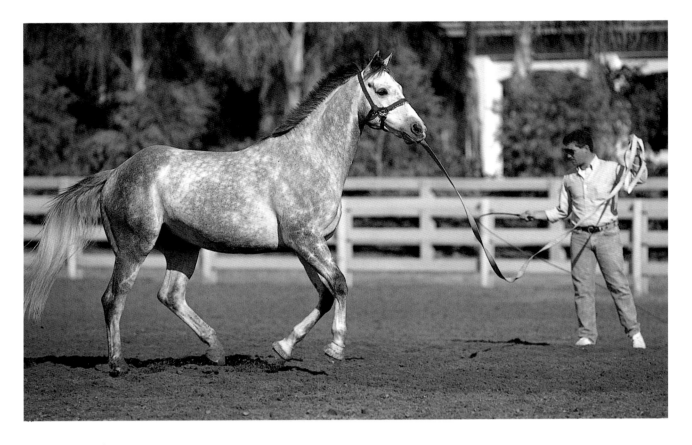

Part of the process of breaking-in and training a horse involves the use of lungeing. A lunge rein is held by the trainer who, by use of a long lunge whip, encourages the horse to move in a circle. Initially a helper may be needed to lead the horse.

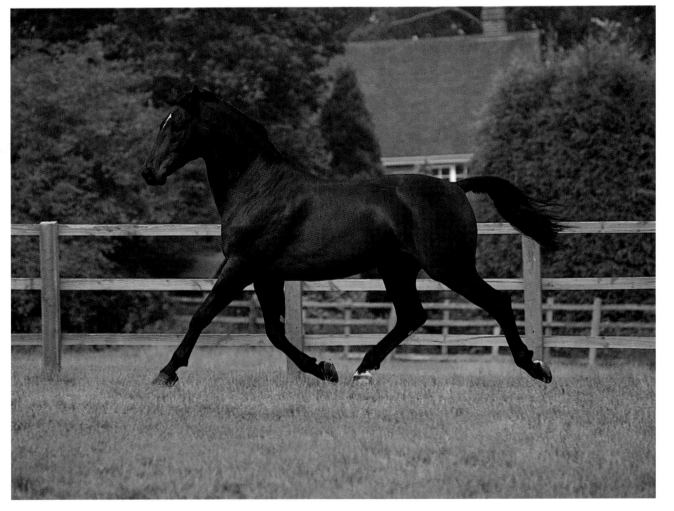

An Oldenburg stallion shows its paces. The breed comes from the region in Germany of the same name and stands roughly 16.3 hands high. A large, robust horse, it is popular both for driving and for riding.

Rearing up on its hind quarters, this Andalusian is an impressive sight. Horses may engage in this behaviour naturally when alarmed but, with patience, can also be trained to do so.

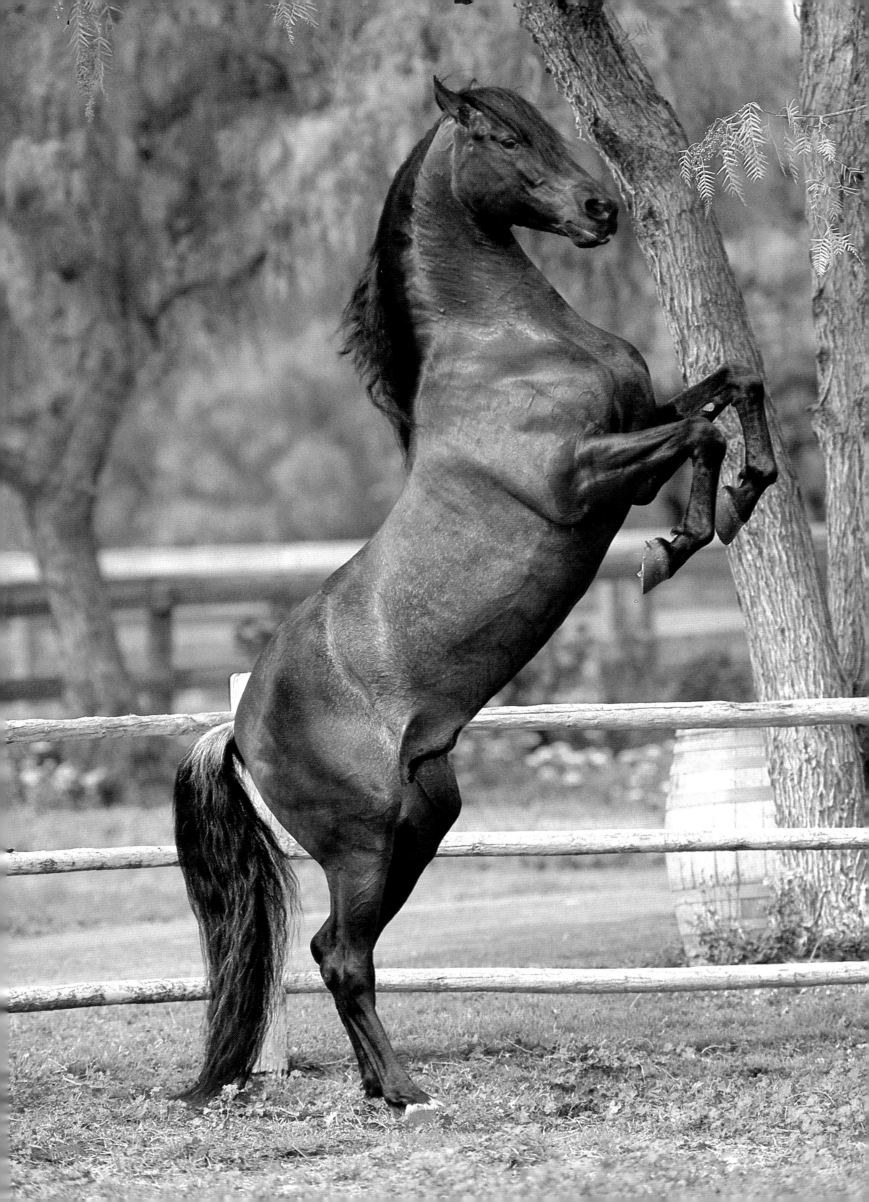

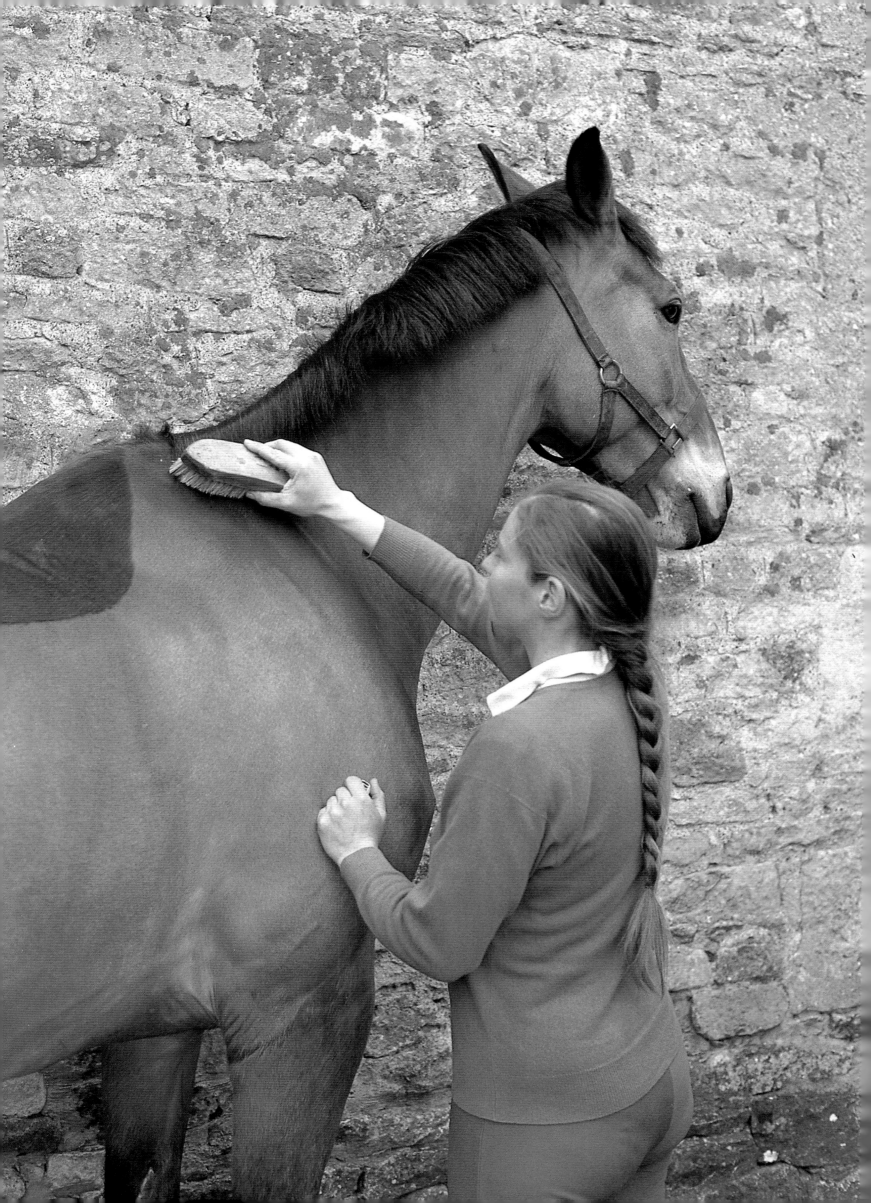

is called a 'blaze'. If the entire forehead is white, stretching laterally from eye-to-eye, then it is called a 'white face'. Other horses may have a white mark between the eyes, called a 'star', or a mark between the nostrils, called a 'snip'. White colouring on the feet is either called 'socks' if they are short, or 'stockings' if they are long.

Care and Attention

Before buying a horse or pony, it is as well to consider the consequences of the purchase. A horse is not simply there for the pleasure of the rider. The rider has a responsibility to the horse for the whole of its life. This responsibility is not to be taken lightly: you literally have the well-being of the horse in your hands.

Horses can either be kept in stables or fields. In most cases, a combination of the two is the most satisfactory arrangement, stables providing shelter at night and during severe weather and the open fields a place for exercise and feeding.

Ideally, a field should be at least eight acres in size and contain good grazing on grass and a mixture of herbaceous plants. There should be an adequate supply of water, whether a stream or a trough, and there should be shade and shelter as protection against excessive sun or wind. Stables should have proper drainage and be well ventilated but not draughty. They should contain a fresh source of water for the horses to drink and adequate

Contrary to what one might expect, horses thoroughly enjoy swimming. From the owner's point of view, the horse gets some exercise while at the same time experiences a good wash.

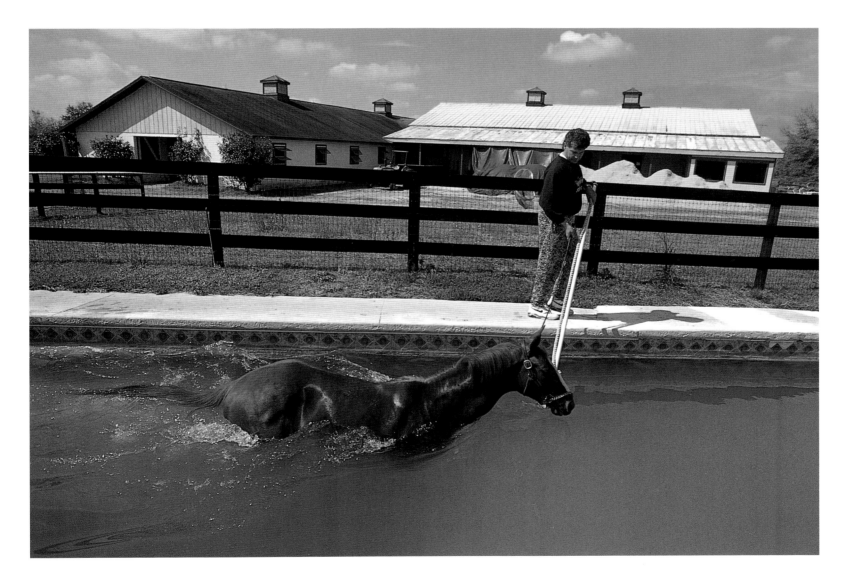

Regular grooming is essential for the well-being of horses. It helps clear dust, mud, and matted, dried sweat from the coat. In addition, horses clearly enjoy the process for its own sake.

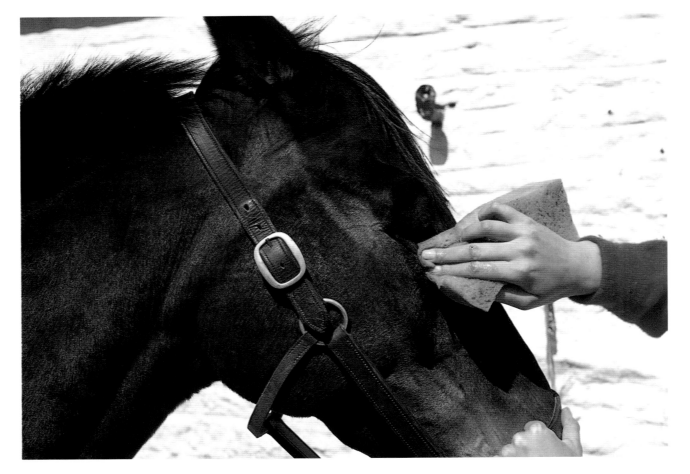

On a daily basis, a horse's eyes should be carefully washed and cleaned, preferably after exercise. Using a damp sponge or cloth, a gentle wipe should be applied in the direction of the muzzle.

Clipping the coat of a horse enables its skin to breathe more easily and to reduce sweating. It should be carried out in a gentle manner so as not to hurt or alarm the horse.

feeding arrangements. For most horses and ponies, round-the-clock stabling is desirable only in severe winter weather. For most of the year, they can roam the fields by day but be stabled at night.

Careful thought should also be given to the suitability of the grazing for your horse. During the summer months, grass and meadow plants form a perfectly adequate source of nutrition. However, from autumn to spring, you will need to supplement your horse or pony's diet with hay or oats to ensure a balanced nutritional input. Keep an eye on the plants growing in the field. Although most are harmless to horses, a few species are poisonous. Among these, most notably, is ragwort, which should be pulled by hand if possible.

Shoes and Tack

Because horses are often ridden on rough ground or on roads or concrete, the hooves may wear out faster than they can grow. Under most circumstances, therefore, it is important to have the hooves shod. A metal shoe prevents wear and tear to the hoof itself but should be replaced at regular intervals and checked to make sure it has not worked loose. You should only use an experienced farrier when re-shoeing a horse.

Saddles and bridles are important items of tack and essential to the comfort and safety of both rider and horse. A saddle should fit snugly on the horse's back but not rub or interfere with the muscles of the withers that are used in running.

Constant Care

It is the responsibility of the horse's owner to check the well-being of the animal. By watching for warning signs, you may be able to spot the early stages of an illness and, at the very least, you can spare your horse any prolonged discomfort by your vigilance.

On a daily basis you should check thoroughly for any cuts or bruises, which should then be treated with an appropriate medication or bandage. Make sure that your horse is inoculated against diseases such as tetanus, a killer if left untreated. Other external symptoms to look for include undue sweating, lack of appetite, sensitive areas, and irritability. These may reflect a more serious internal condition. Consult a vet in these cases.

Regular shoeing is vital to avoid damaging the hoof of the horse and should be performed only by an experienced farrier. Prior to a new shoe being applied, the old one is removed and the hoof is thoroughly cleaned.

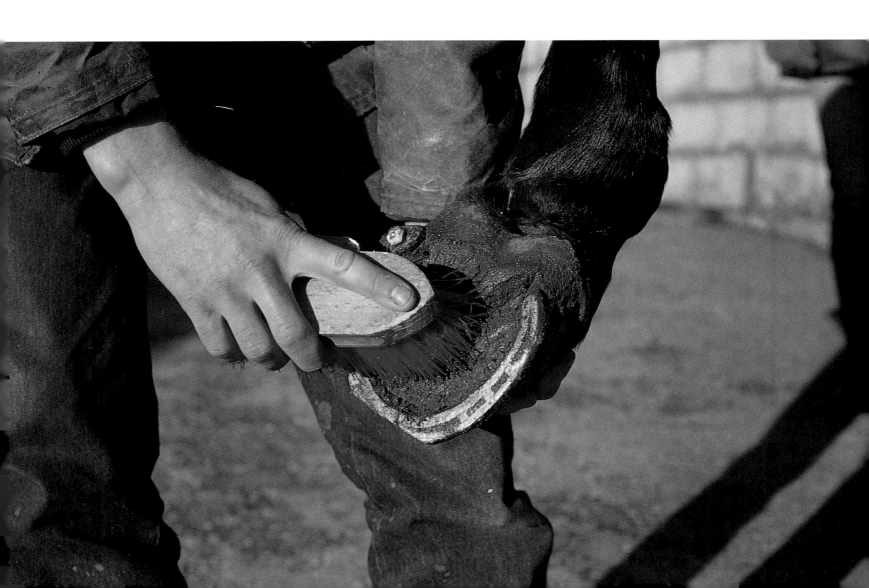

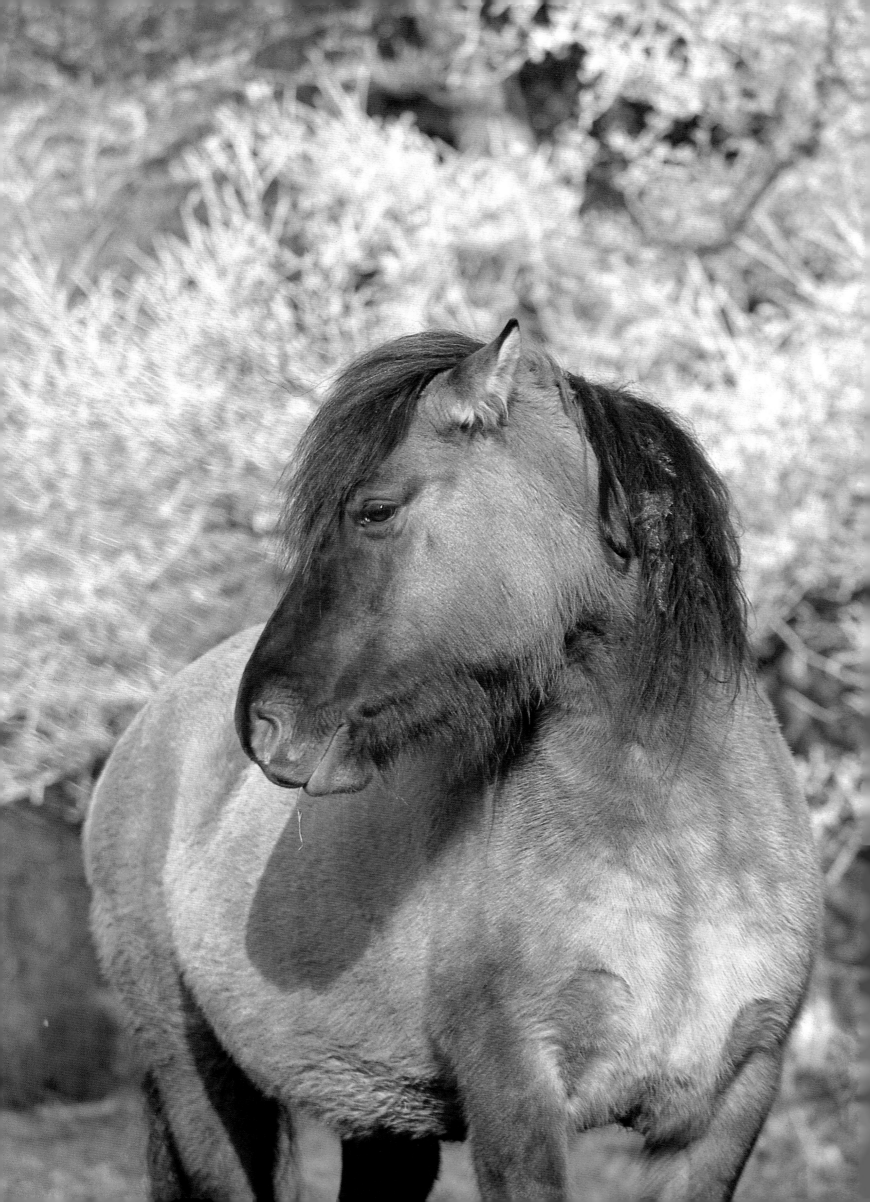

PONY BREEDS

Over the thousands of years that man and horse have been associated, selective breeding has been applied to develop or emphasise features of the horse's anatomy or physiology. Breeds have been developed for their size and strength while, in others, speed may have been the desired characteristic. In this chapter and the next, various breeds from around the world will be described. This chapter deals with ponies—horses less than 14 hands high—and the next one with horse breeds.

A breed is not just an arbitrary term but a category of horses that has a stud book, and thus a record of their ancestry. Stud books for certain breeds simply accept parents with suitable characteristics acceptable to the breed authorities. The most pure breeds, however, require the parents to be registered members of the breed before the offspring is accepted. A few of the horses and ponies described are not registered breeds. They do, however, conform to a recognised appearance and are also worthy of consideration.

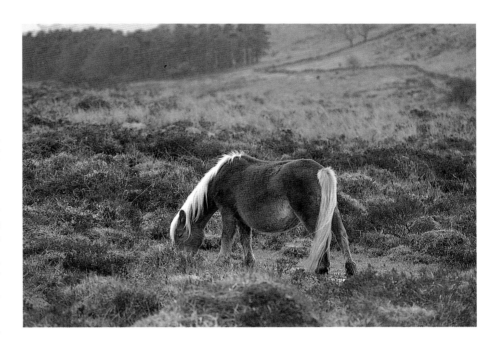

Pony Breeds of Great Britain and Ireland

Breeds and types of horses and ponies were usually developed within comparatively small geographical areas, their characters being suited to the particular needs of the local people. Nowadays, however, the role of ponies and horses often has more to do with leisure and sport, and so members of breeds are often found around the world.

One of Britain's best-known breeds, the Dartmoor pony comes from the moorland region in Devon of the same name. They are tough, hardy animals that find popular use as riding and trekking ponies.

The Exmoor is generally reckoned to be the oldest pony breed in Britain. They still roam wild on the moors of the same name in north Devon and Somerset but are also popular as trekking animals.

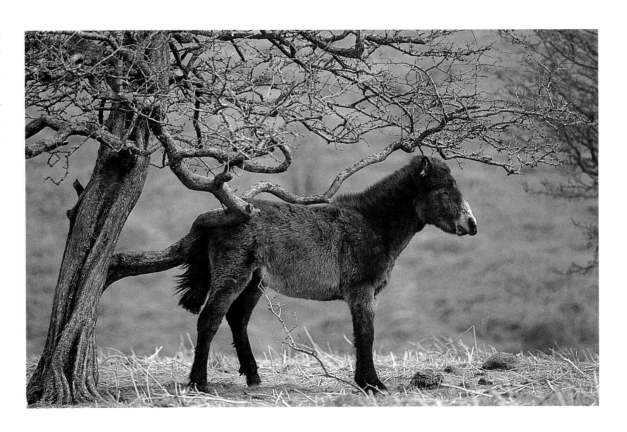

Developed as a crofters' work pony in western Scotland and the Western Isles, the Highland pony is a tough and durable breed. Its stocky build and sure-footedness mean that it can work on very uneven ground.

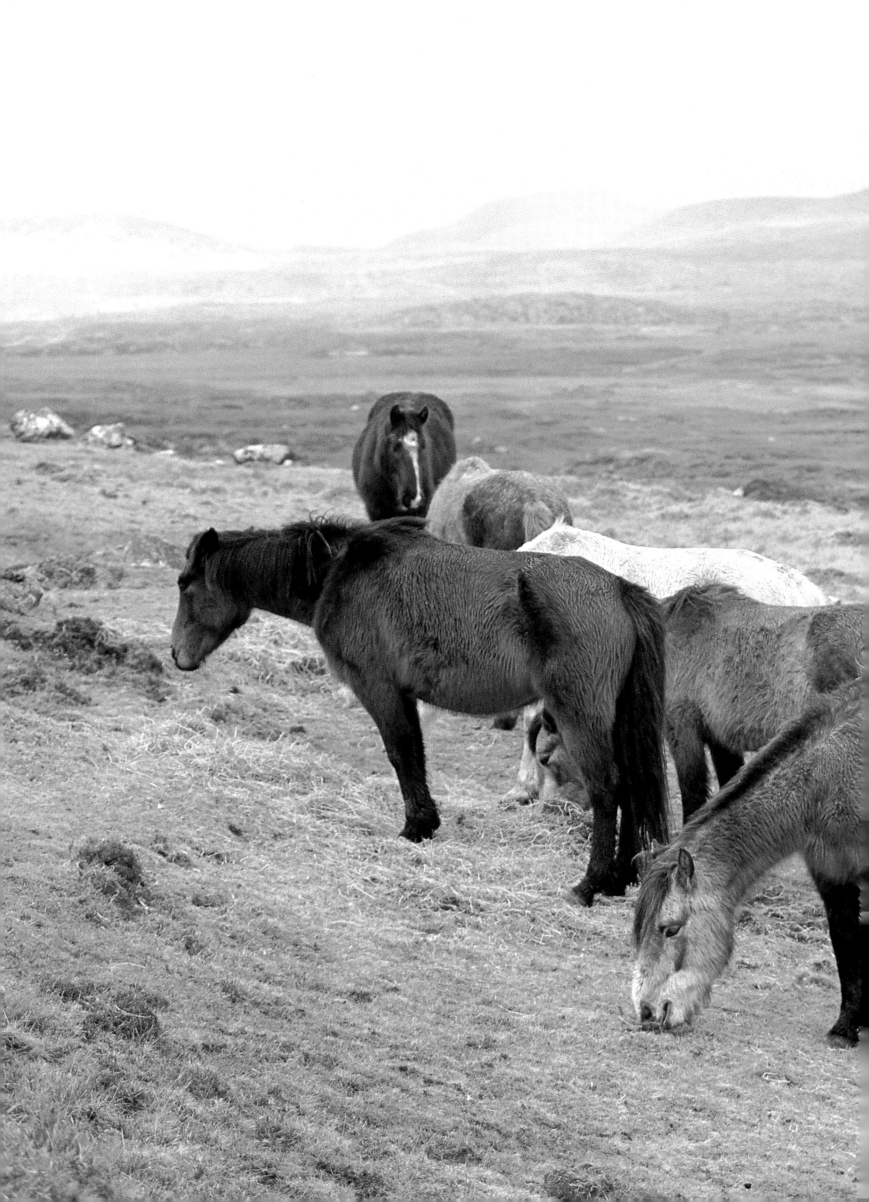

Ponies were developed as sturdy working horses whose hardy physiology suited them to the rigours of outdoor life. This is true of many of the breeds from Great Britain, of which nine are native. Most originated from rural and often rugged parts of the country, such as stretches of wild moorland or hill and mountain regions.

One of the best-known breeds in Britain is the New Forest pony. The ponies still live wild in this well-known area of ancient hunting forest and heathland in Hampshire, from which it gets its name. New Forest ponies can trace their ancestry back to the Domesday Book of 1085. Centuries of dilution with other breeds have created considerable variation in their appearance. They are usually between 12.2 and 14.2 hands high and can be almost any colour, although bay is most usual. The climate and terrain of the New Forest is often challenging, and the ponies are hardy. They are popular with riding schools in the area.

Two other well-known breeds are found in moorland regions of southern England, these being the Exmoor and the Dartmoor. Exmoor ponies are a very old breed, also mentioned in the Domesday Book of 1085, and come from the Exmoor region of north Devon and Somerset. They stand 12 hands high and are mostly bay or brown in colour with a pale, mealy muzzle and mealy colouration around the eyes. Accustomed to the rigours of Exmoor weather, they are hardy and make excellent riding ponies.

Dartmoor ponies come from their namesake region in south Devon. They stand 12.1 hands high and are stockily built with a relatively small head and strong shoulders. Dartmoor ponies may be bay, brown, or black in colour with only limited amounts of white. They make good riding ponies.

A small herd of Connemara ponies grazes on open moorland in their native Ireland. The breed arose in County Connaught and is a popular riding horse, standing 13.2 hands high.

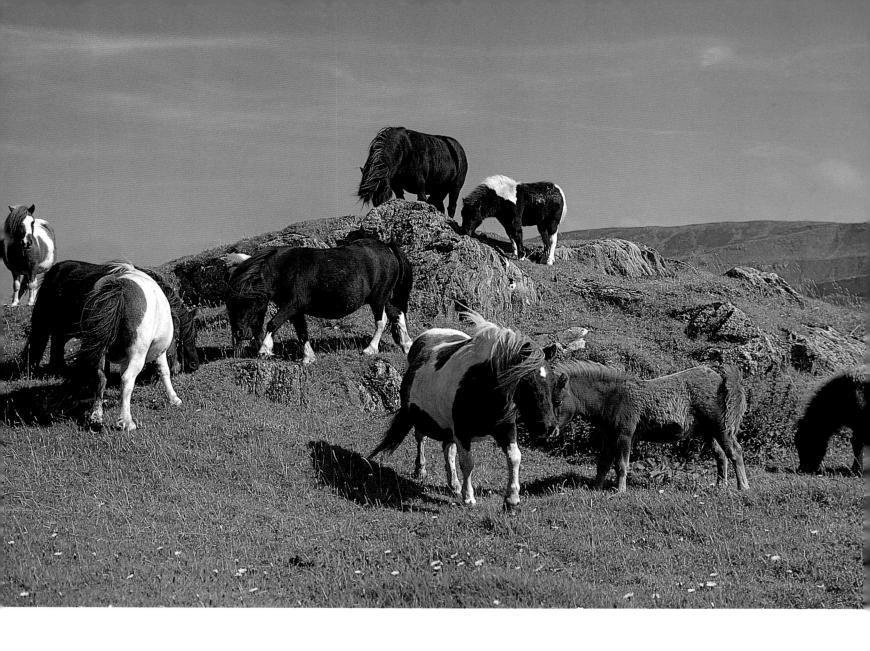

Two familiar and popular pony breeds come from Scotland. Perhaps best known of these is the endearing Shetland pony, highly popular as a small child's riding pony. The breed comes from the Shetland Islands which lie one hundred miles off the north coast of Scotland. Originally developed as a working horse for crofters, they found a role in the nineteenth century as pit ponies, exported to work in mainland mines. Nowadays, mechanisation has abolished their working role and they are mainly in demand as riding ponies. Small herds still roam the moors of the Shetland Islands. The Highland pony comes from the highlands of north Scotland and the Western Isles. They vary between 13 and 14.2 hands high and are usually dun, grey, black, or bay in colour.

The north of England has also produced two hardy breeds. The Dale comes from the eastern side of the Pennines and stands 14.1 hands high. It is a sturdy, heavy pony, generally dark in colouration with little or no white, except perhaps a star on the face.

They were originally bred for use as pack animals and can haul heavy loads. Today, this makes them ideally suited for being harnessed or used in pony trekking. Its nearby relative, the Fell pony, comes from the Lake District to the north and west of the Pennines. It stands 13.2 hands high and is less robust than the Dale. It was also used as a working animal, carrying heavy loads over the moors. Fell ponies are usually dark in colouration.

Wales is a land of rugged, often mountainous terrain which has also produced several breeds of hardy, working ponies. Best known, perhaps, is the Welsh Mountain pony, which is as popular today as it has always been. It stands 12 hands high and should be of uniform colour, usually grey, chestnut, or brown. Welsh Mountain ponies make excellent riding ponies for children, being even-tempered and intelligent.

The Welsh pony has its origins in Welsh Mountain, Welsh Cob, and Thoroughbred stock. It is a classic riding pony and stands

13.2 hands high. The colouration should be uniform and is often grey. Their hardy natures make them ideal trekking ponies.

The Welsh Cob is the largest Welsh pony breed, standing between 14 and 15.1 hands high. It has uniform colouration and is often dark. It is powerful and has great endurance, making it suitable both for riding and driving.

Although fairly widespread now in Britain, the Connemara pony comes originally from County Connaught in the west of Ireland. It is descended from Celtic pony stock, but over the centuries the introduction of Spanish and Arab blood has created this elegant breed. It stands 13.2 hands high and makes an excellent pony for riding and jumping. The colouration is uniform and usually grey, black, dun, or bay.

European Ponies

A wide range of pony breeds may be found in mainland Europe as well. One of the most attractive of these is the Camargue pony, whose free spirit is evocative of the romantic setting from which it takes its name. The Camargue is a land of wetlands, marshes, and plains which make up the delta of the river Rhône in the south of France. Characterised by their white coats, Camargue ponies can be seen in small herds in wet areas. They are often used by local

With the constant companionship of cattle egrets, a wild Camargue pony grazes the saline-tolerant grasses that flourish in a brackish lagoon. Hardy animals, these ponies spend much of their time wading through water.

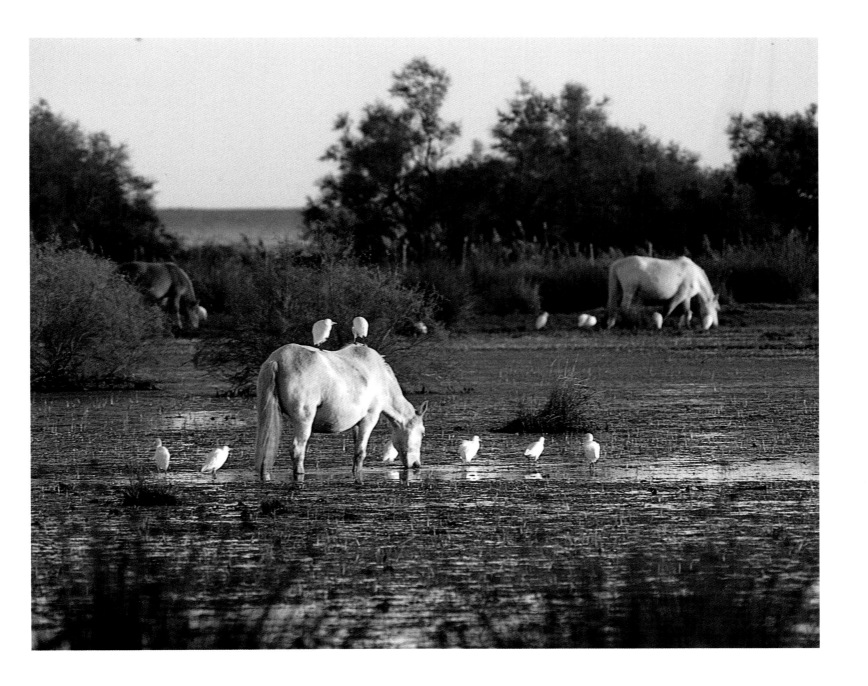

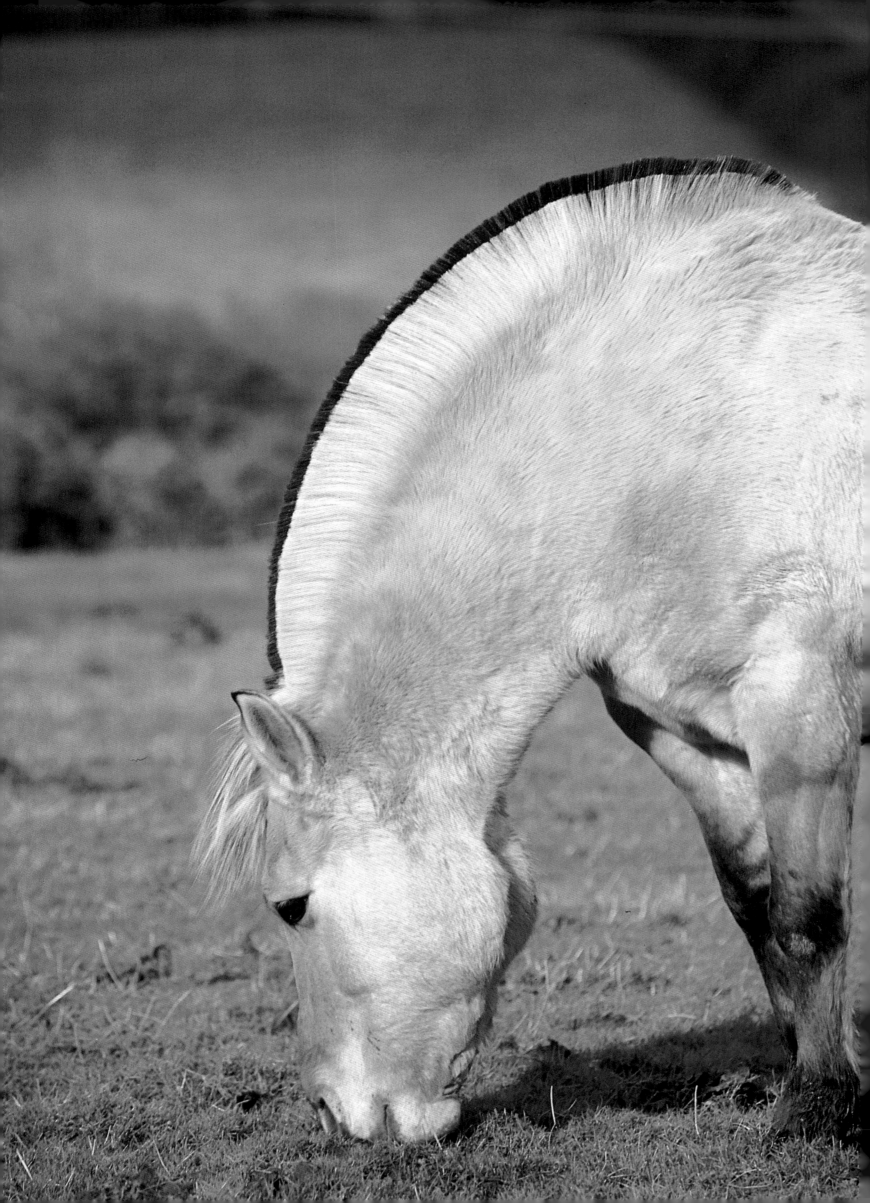

people to round up the region's black bulls, destined for the bullring. Full grown Camargue ponies can reach 15 hands high. Although white when adult, the foals are born with a brown or grey coat.

Most other countries in southern Europe also have their own breeds of ponies, developed to assist in agricultural work and as pack animals. From the border regions of Spain and Portugal comes the Sorraia. This ancient breed was one of the first ponies to be domes-

ticated and was used for ploughing fields and herding cattle. It stands 13 hands high and is usually dun in colour. The Garrano or Minho pony comes from the Garrano do Minho mountains in Portugal. It is sure-footed on rough terrain and is excellent both for riding and as a pack animal. It stands 11 hands high and is usually chestnut.

The Haflinger is another hardy, mountain pony which was first bred in the Austrian Tirol. It stands roughly 14 hands high and is

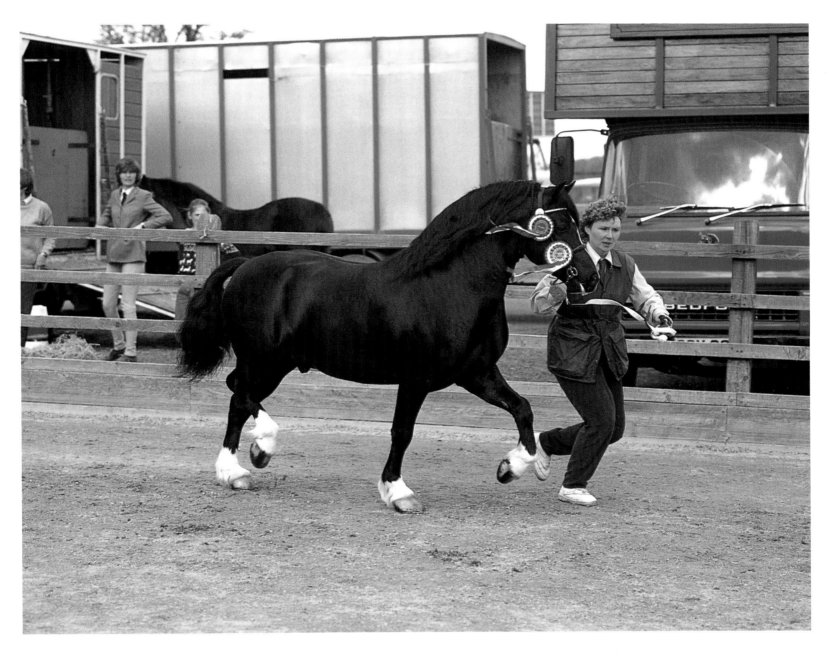

With a breed name like Fjord, this has to be a horse with Scandinavian origins. In fact, the breed comes from Norway and its powerful build was used to good effect working the land and transporting heavy loads.

The Welsh Cob is a large pony, standing more than 14.2 hands high. The breed has been established for several centuries and is now used for jumping and trotting, both tasks being performed with characteristic enthusiasm.

a uniform chestnut colour with a paler mane and tail. Because of the rugged nature of its home environment, Haflingers are sturdy and strong. They are also extremely sure-footed and make good riding ponies. The home of the Haflinger is now in northern Italy, the region where the Avelignese pony also originated. It is rather similar to its cousin, as it is descended from Haflinger and Arab stock. Bred in the Alps and Apennines, the sure-footed Avelignese is a good trekking pony.

Northern Europe also has its fair share of pony breeds. From Poland come two ancient breeds, the Hucul and the Konik, the former from the Carpathian mountains and the latter from eastern Poland. Both are thought to descend from the tarpan, an eastern European subspecies of the wild Przewalski's horse, now extinct in its true form. Huculs and Koniks stand 13.2 and 13.1 hands high respectively, and both are hardy and strong,

To their owners they are a delight. To an onlooker, however, the sight of miniature ponies pulling a carriage can look faintly ridiculous. Whatever your thoughts about the spectacle, the ponies seem to be enjoying life.

making them ideal for agricultural work and as pack animals.

From Scandinavia come the Fjord pony from Norway, the Gotland from Sweden, and the Icelandic pony. All three are sturdy creatures, able to cope with the rigours of harsh winter weather. The Fjord stands 14 hands high and is cream or dun in colour. It is powerfully built with a relatively small head, and is ideal for carrying loads or working the fields in mountainous regions.

The Gotland originally came from the island of Gotland. It stands 12.1 hands high and is black, brown, chestnut, or dun in colour. They make good children's ponies but continue to be used for agricultural work. The Icelandic pony originates from Norwegian stock, mixed with Scottish and Irish blood. It stands 12.2 hands high and is usually dun or grey with a thick mane. The small size and relative strength of the Icelandic pony caused it to be in great demand as a pit pony in

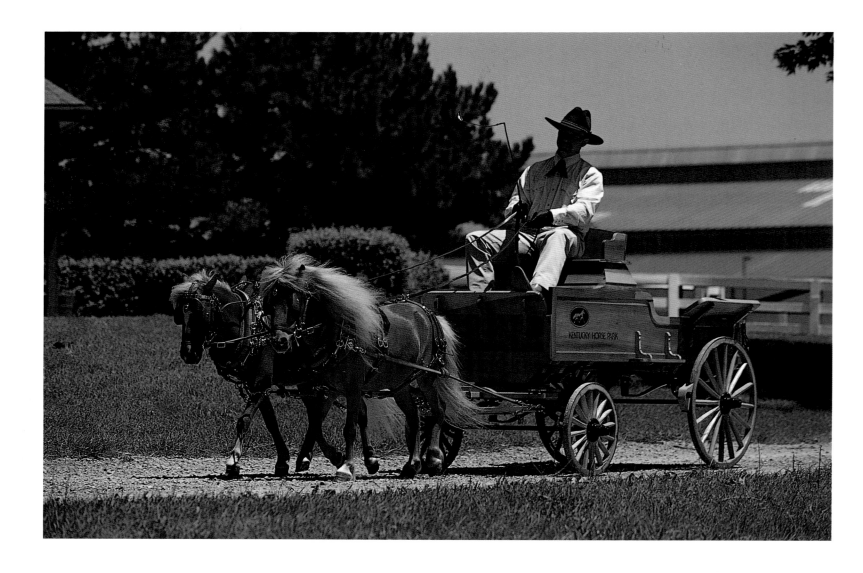

British coal mines until comparatively recently.

American Ponies

Although many of Europe's pony breeds are popular in North America, a successful breed has also been developed there. Called the Pony of the Americas, the breed came into being in the 1960s, born to a Shetland stallion and an Appaloosa mare. It stands 12.1 hands high and is unashamedly a children's pony. It is also used as a trail-riding pony.

From across the border in Mexico comes the Galiceno pony, a descendent of Garrano and Sorraia ponies brought over by Spanish

Standing less than 7 hands high, this miniature Falabella is almost dwarfed by a field of daffodils. The breed is in demand most as a pet, although it is sometimes ridden in harness.

The small but sturdy Icelandic pony was developed to endure the rigours of its namesake island's winters. Used initially as a pack animal, it found a subsequent use as a pit pony in Britain's coal mines.

settlers. It makes a good riding horse and is also used for ranch work. From further south, the Criollo is a popular pony breed, standing 14.2 hands high. It is a sturdy pony with relatively short legs and makes an ideal ranching horse. It can be found from Brazil southward throughout South America. Lastly, mention must be made of the famous Falabella pony. Originally from Argentina, it is the smallest pony in the world, standing 7 hands high. Although occasionally seen in harness, the role of the Falabella is really that of a pet.

Originally developed in Hafling in the Austrian Tirol, the Haflinger is a hardy, outdoor pony. Its main use was in mountain work for which its sure-footedness and stamina were great assets.

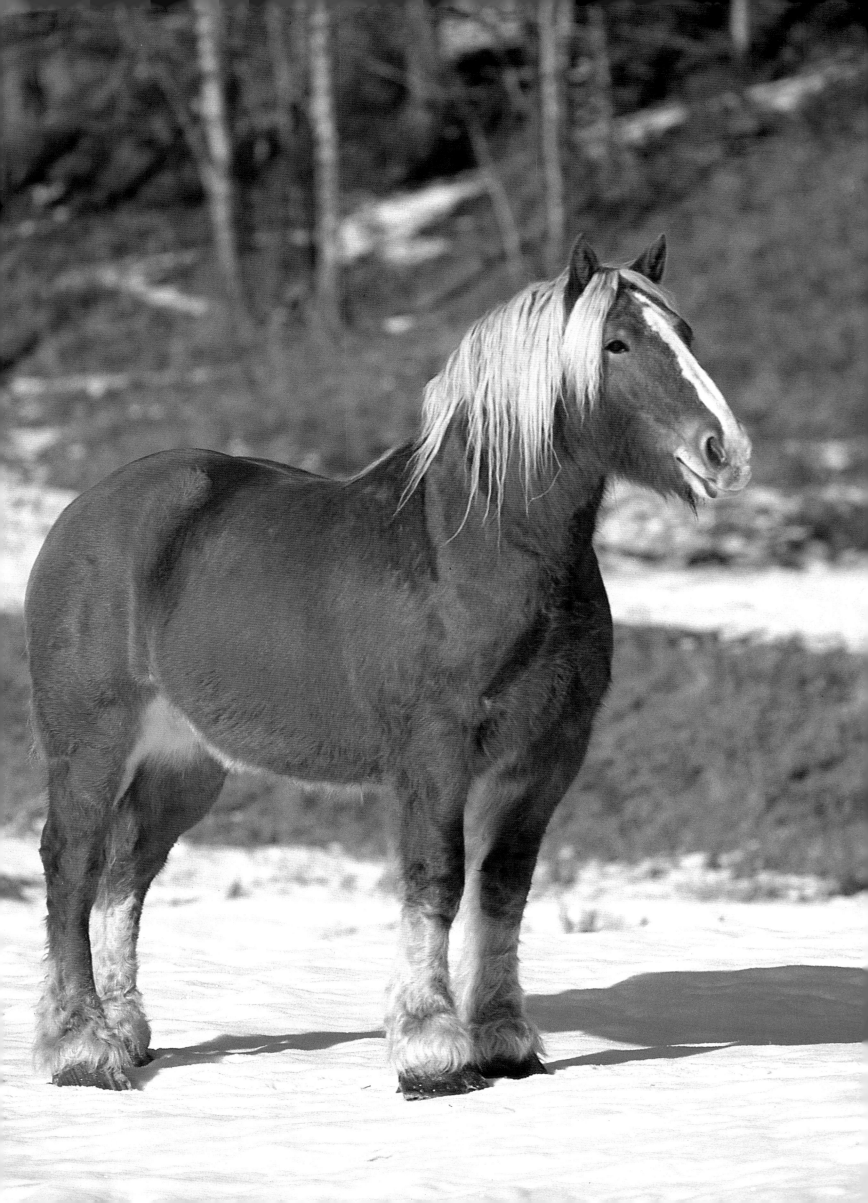

HORSE BREEDS

Heavy Horses

Throughout the horse breeding world, large, heavy horse breeds have been developed to assist in agricultural work such as ploughing or pulling heavy loads. All share massive size, especially well-developed shoulders, huge legs relative to the size of the body, and large, broad-based feet. Despite these superficial similarities, each breed has its own unique character, developed to suit the needs of the region in which it was developed.

In Britain, one of the best known of the heavy horses is the Shire. This gentle giant is one of the largest breeds in the world and stands 17 hands high. As its name implies, the breed comes from the 'shire' counties of England and it boasts as its ancestor the Old English Black Horse. Shires were originally used for tilling the land and hauling heavy loads until increasing farm mechanisation eventually replaced them with tractors in most areas. However, a few farms still preserve the tradition of using Shires and they are popular at shows.

Incredibly broad, feathered feet are a feature of the Clydesdale, a breed from Lanarkshire in Scotland. The animal stands 16.2 hands high and is a powerfully-built draught horse.

Suffolk Punches graze peacefully in a summer meadow. These large, powerful horses are surprisingly docile, a trait which favoured their use in the past as draught horses both in rural and town settings.

An even temper and heavy build make the Belgian Heavy Draught horse an excellent breed for agricultural work. The legs are thickset and powerful and the feet are broad and feathered.

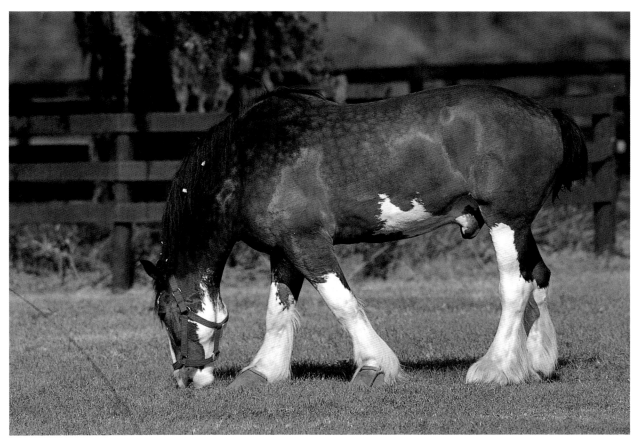

Another well-known breed of heavy horse is the Suffolk Punch. It stands 16.1 hands high, has different proportions than the Shire, and is marginally smaller in build. Suffolk Punches are chestnut and have clean legs while Shires are invariably dark with white markings and have hairy feet and lower legs, referred to as 'feathers'. The breed comes from East Anglia and dates back several centuries. It is still used on farms, but is more usually kept these days for showing or interest.

The north of Britain has also produced a breed of heavy horse. From Lanarkshire in Scotland comes the Clydesdale, a massive horse standing 16.2 hands high, descended from Native Great Horse and Flanders Horse stock. It was developed as a draught horse for which purpose its stout legs and large, broad-based feet serve it well.

Most countries of mainland Europe have developed their own breeds of heavy horse. The ancestor of many of these was the Flanders Horse, a massive Belgian work and warhorse from medieval times. The Belgian Heavy Draught horse or Brabant is a direct descendent and stands roughly 16.2 hands high. It can be grey, dun, or

In everyday life, heavy horses have largely been replaced by the internal combustion engine. They are, nevertheless, extremely popular show animals, often exhibited pulling the wagons and carts that they were bred for.

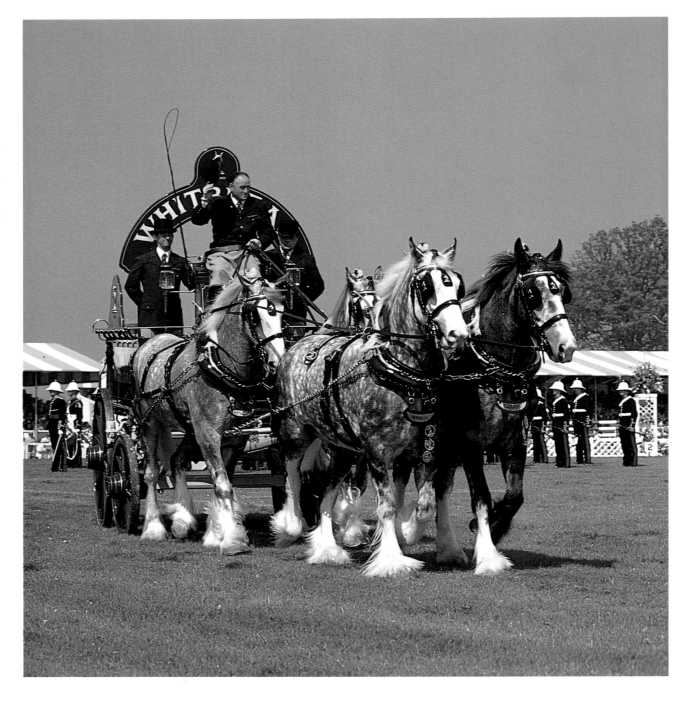

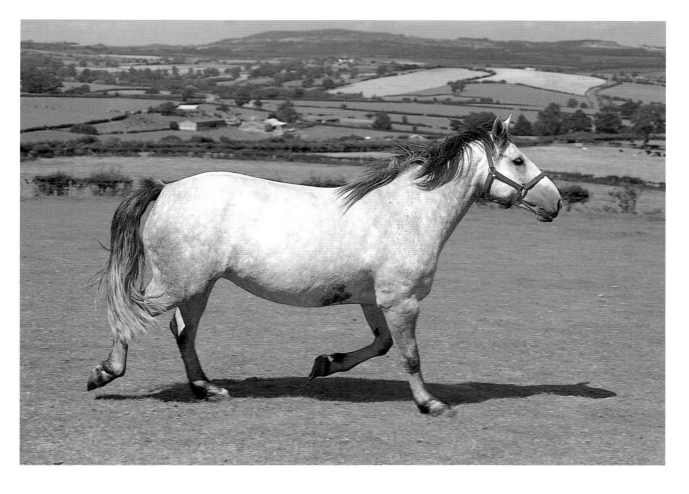

Despite its name, the Irish Draught horse finds more favour these days as a riding horse. Although it has a robust build and relatively short legs, it is a good jumper and is sure-footed on uneven terrain.

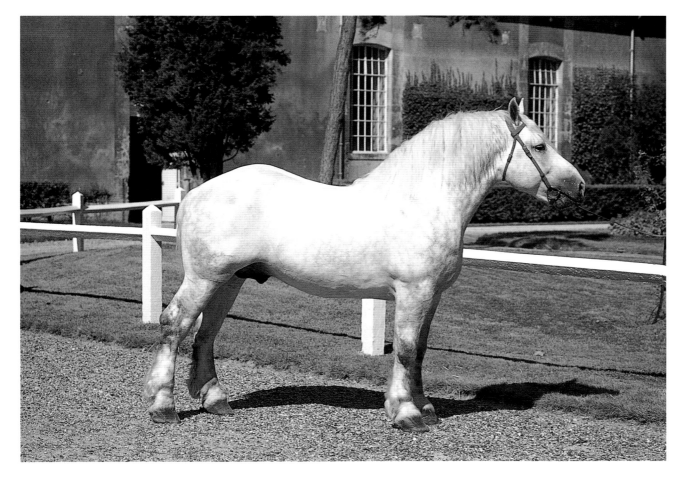

The Boulonnais is a magnificent heavy horse that was originally developed as a draught animal. It comes from northern France and boasts among its ancestors Europe's Great War Horse.

chestnut and is extremely heavily built with a square head.

The Belgian Heavy Draught horse, together with the Ardennes, played a vital role in the development of other heavy breeds elsewhere in Europe. The Ardennes itself is an excellent breed for heavy agricultural work and stands 15.3 hands high. If anything, it is even more stockily built than its cousin, with powerful neck and shoulders.

The rearing of heavy horse breeds reached its peak in France, which boasts more breeds than any other country. Among them are the Breton and the Boulonnais. Arguably the most attractive of these, however, is the Percheron, which is descended from Norman, Heavy Draught, and Arab stock. When full grown, it stands 16.1 hands high and is beautifully proportioned for a horse of its size. The legs are without feathers, the neck is straight and powerful, and the head is heavy. The most attractive feature is the colour and patterning of the coat, which is bay or grey with delicate dappling. Their name derives from their region of origin—la Perche—and they have great stamina.

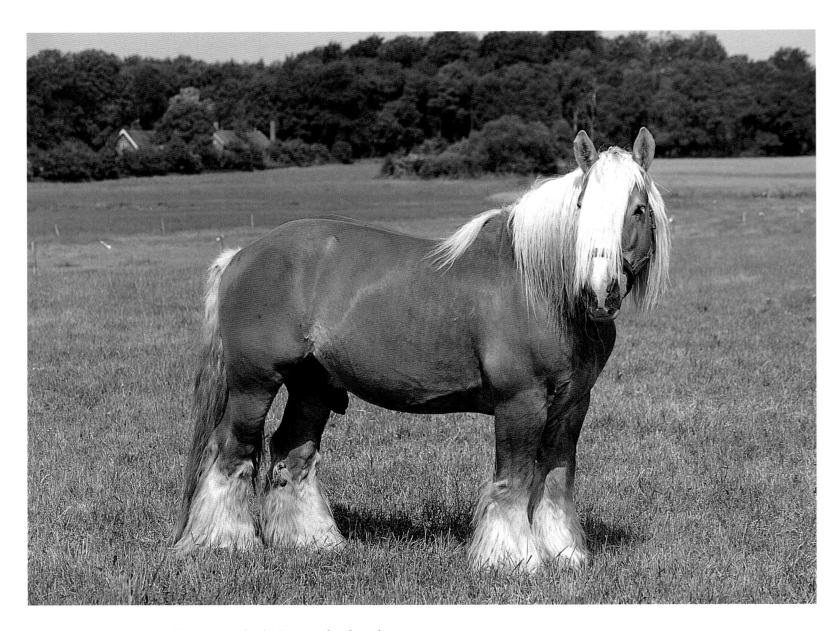

Most countries in Europe developed their own breeds of heavy horse, each best adapted to the type of draught work appropriate to the region. This Jutland comes from Denmark and stands 15.3 hands high.

As can be seen from its thickset neck, the Breton is a sturdily built heavy horse. It is extremely strong, has an even temper, and is ideally suited to the agricultural work for which it was developed in France.

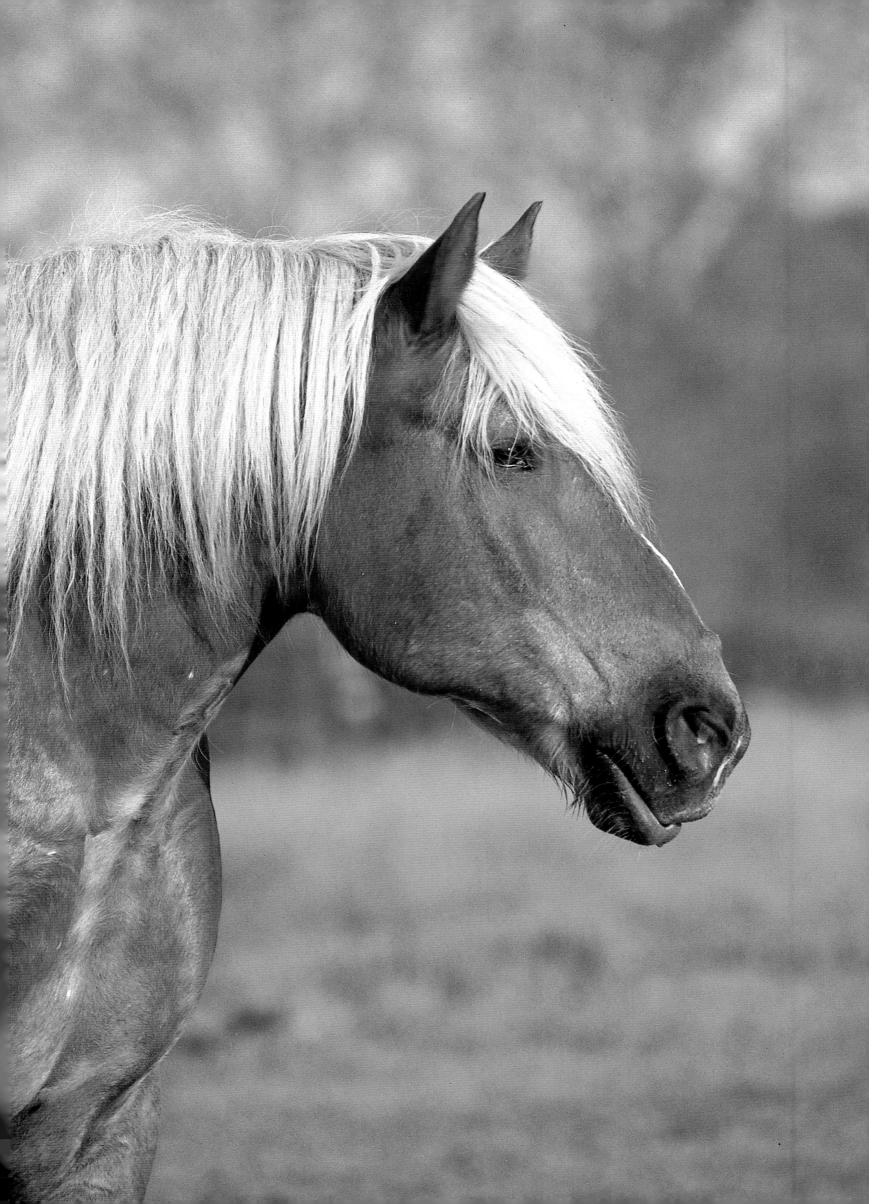

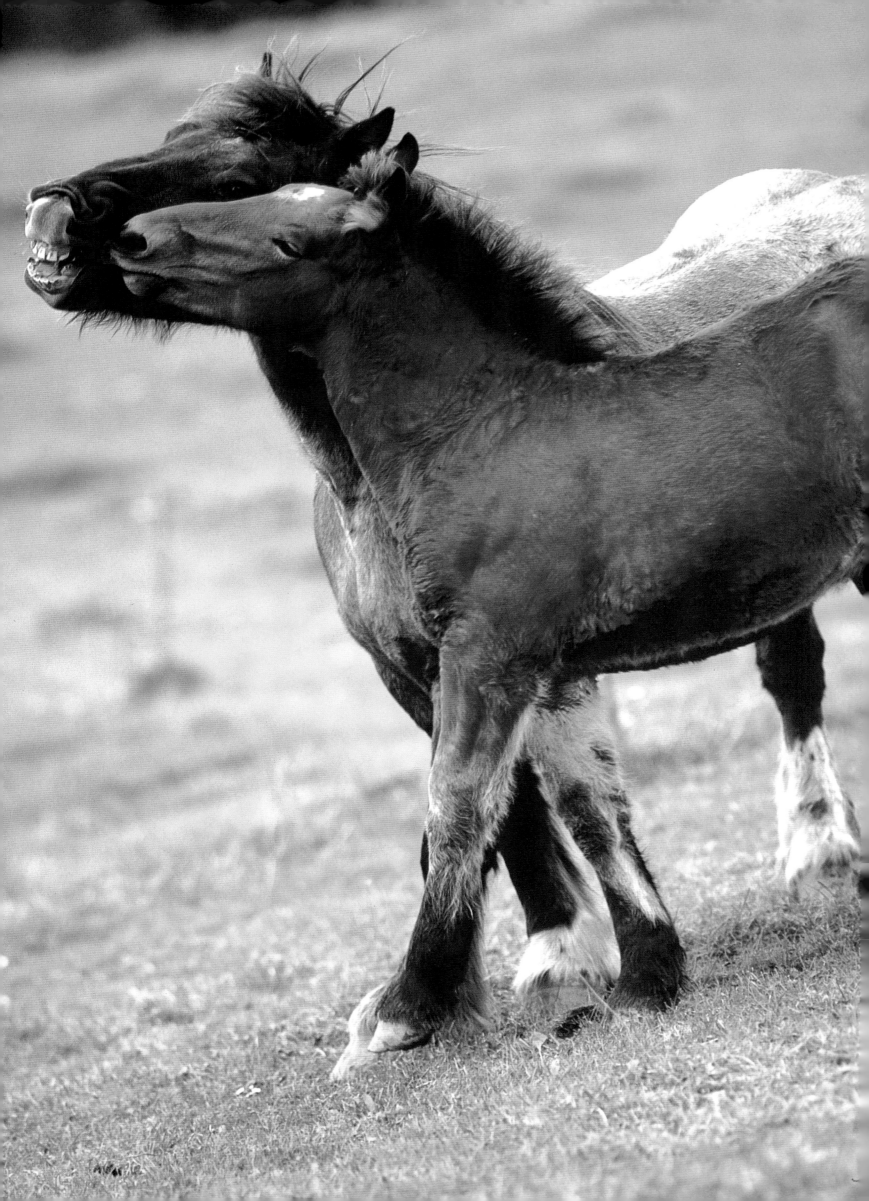

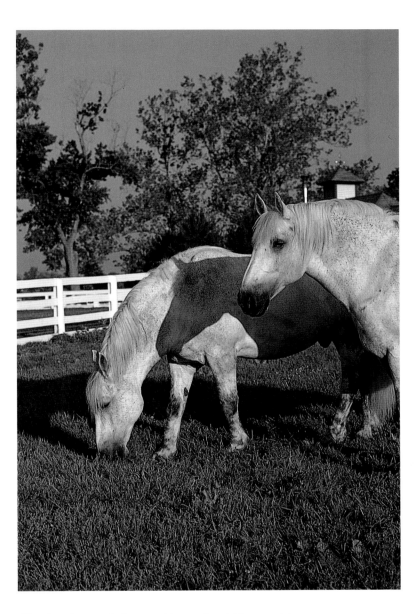

The Percheron is known throughout the world as a superb heavy horse. Originally developed in France as a draught animal, they are capable of pulling immense loads with seemingly little effort.

The Ardennes is a classic of its kind. Originally from Belgium, this heavy horse was developed for use on the land and is incredibly strong. Here, a mare and foal enjoy each other's company.

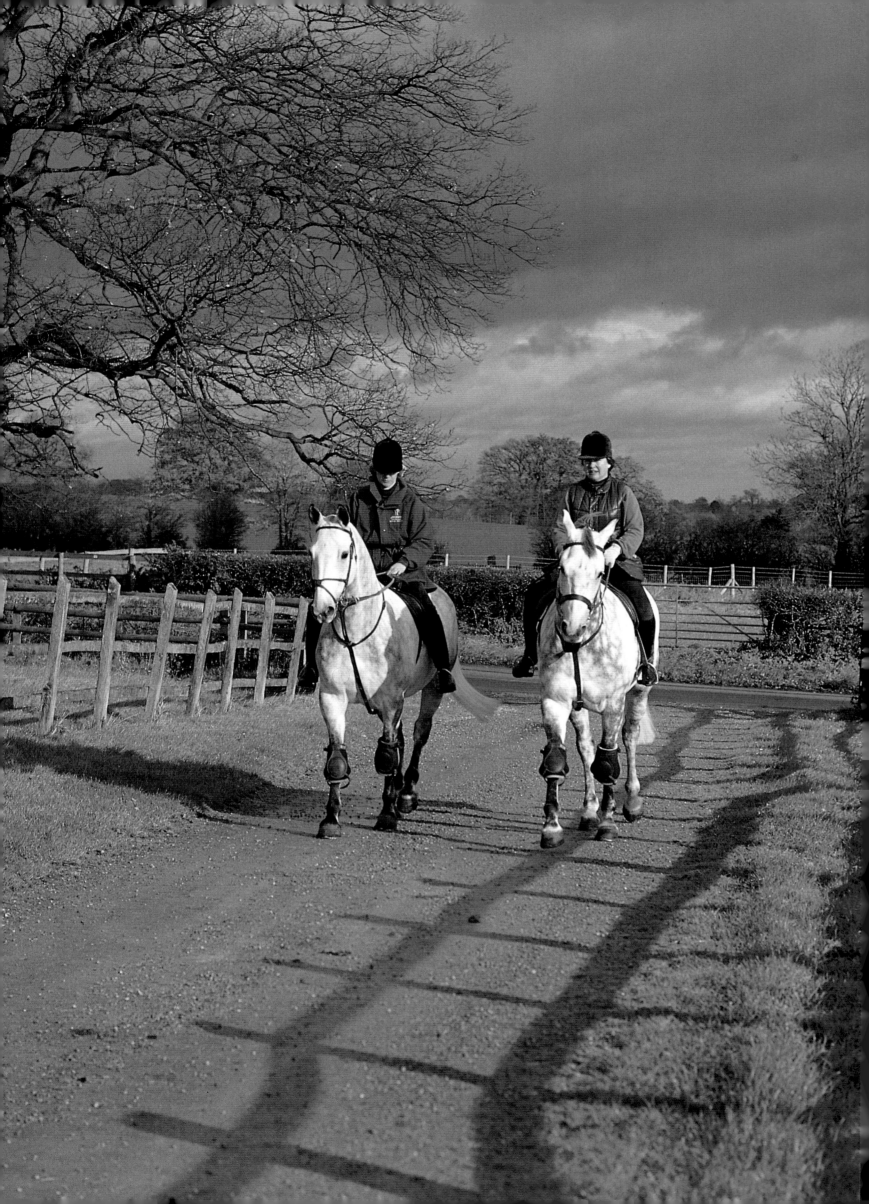

Breeds for Riding and Pleasure

Throughout the long history of man's association with the horse, breeds have been developed for riding. In the past, the role of a large proportion of these horses would have been to assist man's endeavours in the fields of agriculture and commerce. However, horses have always been kept for fun and pleasure as well. Centuries ago, it would only have been the wealthy and privileged who could afford this luxury. Nowadays, however, in Europe and North America in particular, riding for pleasure is the most important function of the horse.

Breeds destined to be ridden have always had attributes such as speed, endurance, good temperament, and manoeuverability emphasised. Although each breed has developed a unique set of characteristics, almost all breeds associated with riding have one thing in common. This is a shared infusion of blood in their ancestry from one ancient and revered breed in particular. The bloodstock is that of the Arab, the oldest pure breed of all.

Some women riders choose to ride side-saddle. Although the position may be comfortable at a slow pace, it is impractical when attempting to ride at speed.

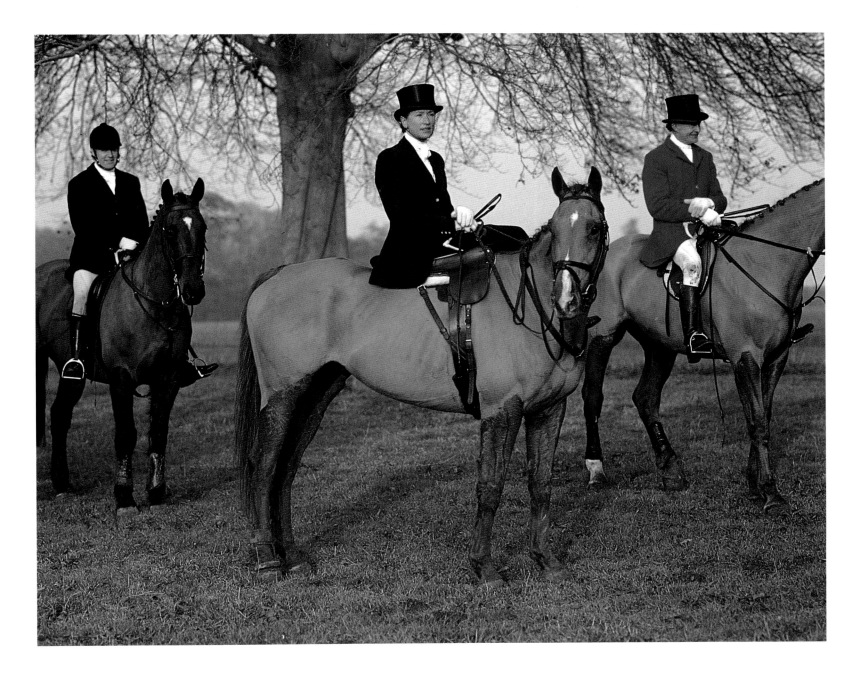

With the morning's chores over, a couple of riders enjoy a quiet ride along a country lane. Both horses and riders alike gain benefit and confidence from the company of others.

Dwarfed in terms of size and power, a jockey urges his mount toward the end of the race. Successful jockeys are as highly prized as victorious horses and are paid handsomely for their efforts.

It is widely held, although difficult to substantiate, that the Arab is derived from horses that ran wild in the southern tip of the Arabian peninsula thousands of years ago. The pattern for the breed would have been established by natural selection, with only the fittest animals; and those best adapted to the environment, surviving and breeding.

Man soon began to play a part in this process, selectively breeding domesticated Arab horses until the breed was firmly established. Having evolved and been refined in a harsh, desert environment, the Arab is also, in many people's eyes, the most graceful and noble in appearance of all horses. With so much in its favour, it is surely little wonder that it has had such an influence on the development of horses around the world.

With origins in Britain dating back more than three centuries, the Thoroughbred is the classic racehorse, developed specifically for this purpose. Ancestry including Arab, Barb, and Turk horses and Galloway ponies has produced a horse that stands 16 hands high and has the elegant proportions of a horse built for speed. Within the breed, some individuals excel at sprinting while stamina over longer distances is accentuated

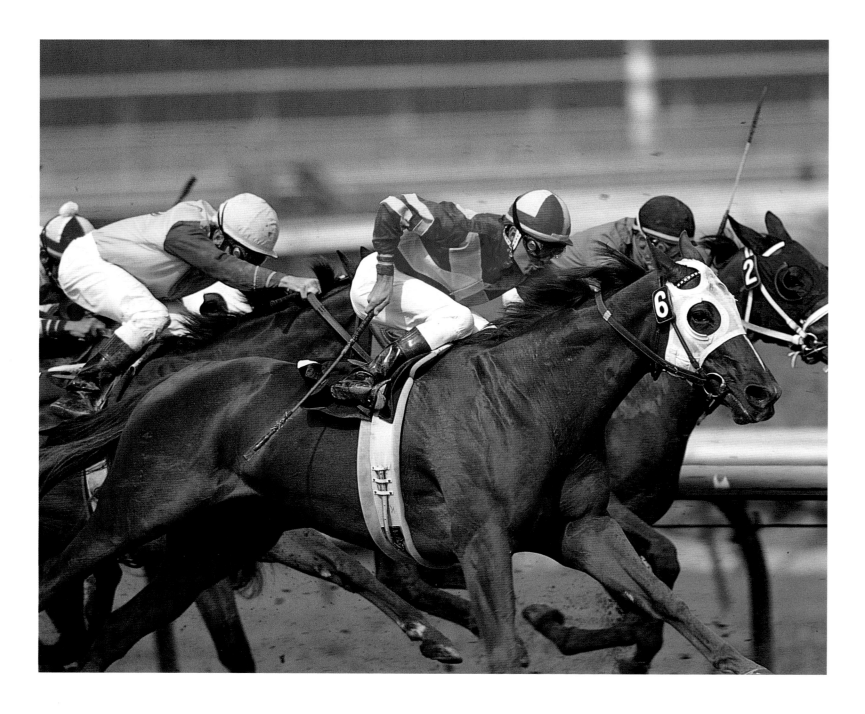

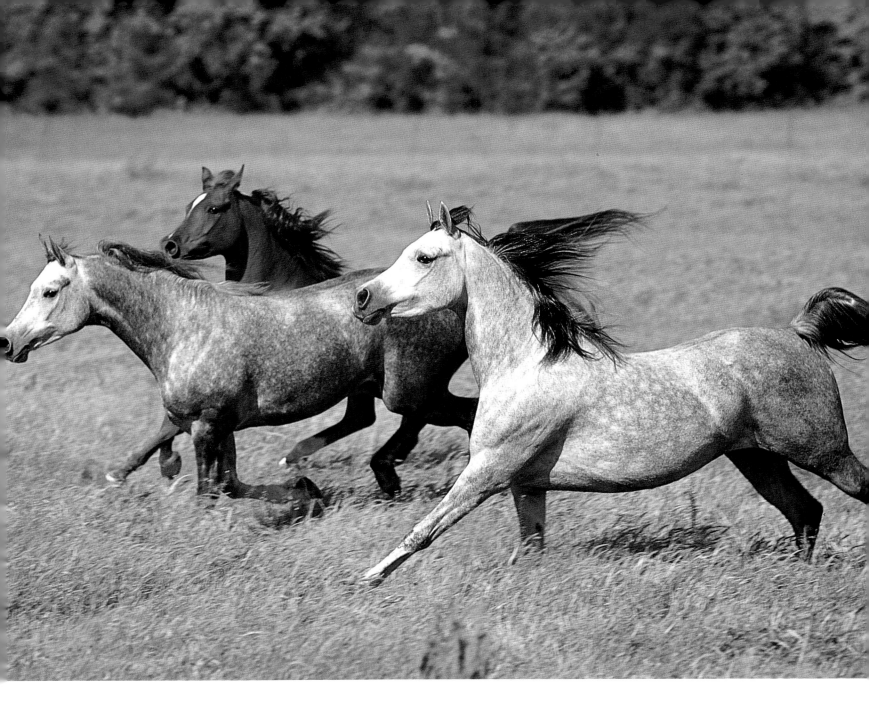

in others. Armed with a knowledge of the traits of particular horses, skilled breeding can create offspring with predictable characters. With this knowledge as a background, the breeding of racehorses has developed into a huge business. While other breeds of racehorse thrive elsewhere in the world, most, if not all, are influenced by the Thoroughbred.

Although not a recognised breed, the Hunter is, nevertheless, a familiar horse type in Britain. It usually has more than a little Thoroughbred blood in its ancestry and thus has good proportions. As its name suggests, the Hunter is used when hunting on horseback, and its constitution suits it to running, jumping, and turning on uneven and uncertain terrain. It is exactly these characteristics, together with its ability to keep its nerve, that make it an ideal horse

for show jumping. Another familiar horse of the show ring is the Hackney, a recognised breed with Norfolk Roadster and Thoroughbred ancestors, and a characteristic high-stepping action. It stands 15.1 hands high and is used almost exclusively for driving carriages.

The influence of the Arab horse can be seen in two of North America's most popular breeds. The Standardbred stands 15.2 hands high and is universally recognised as a superb racing horse. Its ancestry is complex but it includes Thoroughbred and Hackney blood as well as that of Arab stock. Its name comes from the time standard that had to be achieved before it would be considered for breeding. The Standardbred is used extensively for trotting in harness.

The American Quarter Horse is America's oldest breed and is suitable for racing, ranch

The Arab is the oldest breed in the world, dating back several thousand years. They are thought to be descended from animals that ran wild in the Arabian deserts. This harsh environment helped to develop their noble characters.

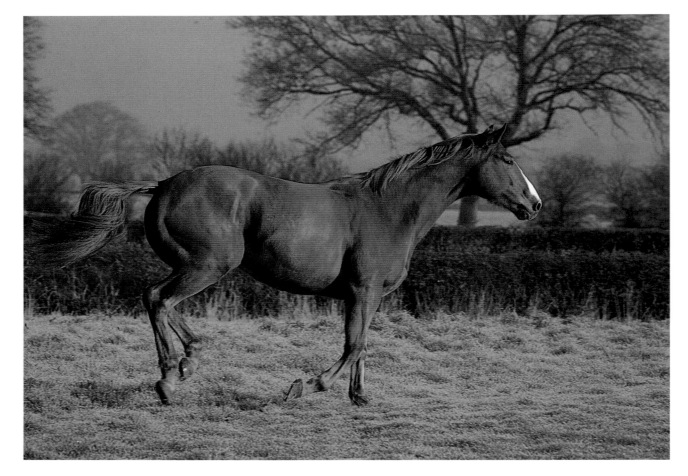

During the winter months, horses are best stabled indoors overnight to avoid catching a chill. In the morning, however, they relish a liberating canter around the paddock.

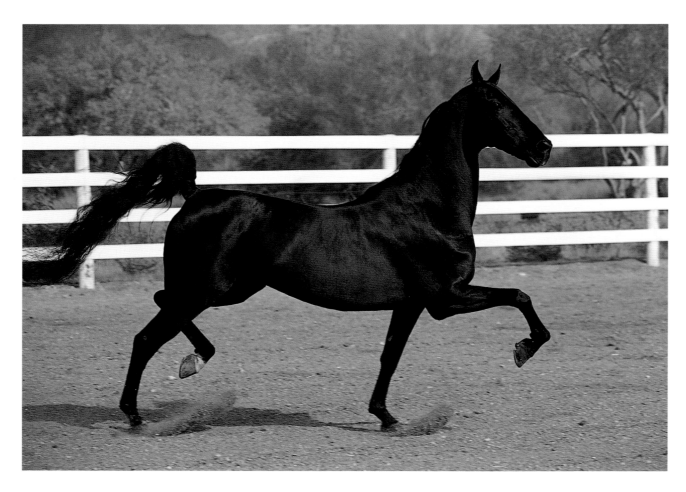

Developed as a breed in the southern U.S., the Saddlebred is a popular show horse. It stands 15.2 hands high and has a high-stepping gait and distinctive profile.

work, and in harness. Early settlers in Virginia and the Carolinas developed the breed from a varied stock, including Arab and Thoroughbred lines, and today's Quarter Horse stands 15.3 hands high and is uniform chestnut in colour. While North America was being colonised, the Quarter Horse was one of the most important breeds associated with the spread of cattle ranching. Another American-bred type, the Saddlebred is a distinctive horse with a rather extraordinary appearance. It stands 15.2 hands high but has proportionately long legs and an elongated body. It is extremely comfortable to ride and is popular in the show ring.

The Palomino, the horse characteristic of Wild West movies, is only recognised as a type. It stands 14 hands high, is uniform golden in colour, and has a beautiful blond mane and tail.

There are, of course, hundreds of other breeds of horses around the world. Most of those associated with riding, however, have got either Arab or Thoroughbred blood in the ancestry, and sometimes both. Although it is not possible to cover the full range of breeds, mention must be made of one of the best known and loved of these, the Lipizzaners. Best known as the mount for the Spanish Riding School in Vienna, this breed dates back to 1580 when Archduke Charles

America's oldest breed, the Quarter Horse, so called because a quarter-mile race was used to test its suitability for the breed register, is still popular to this day. It is used for ranching, rodeos, and for general riding.

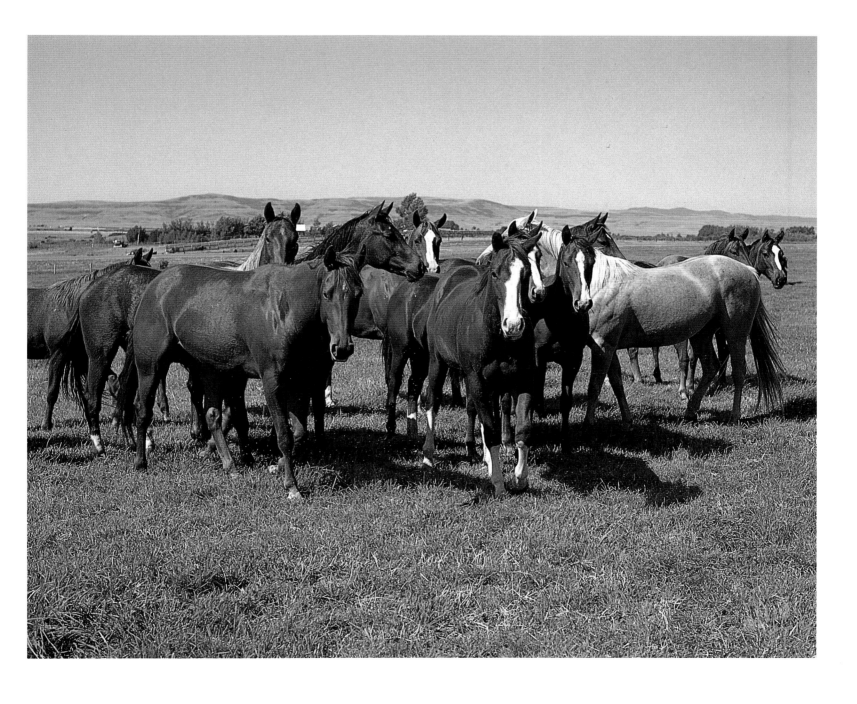

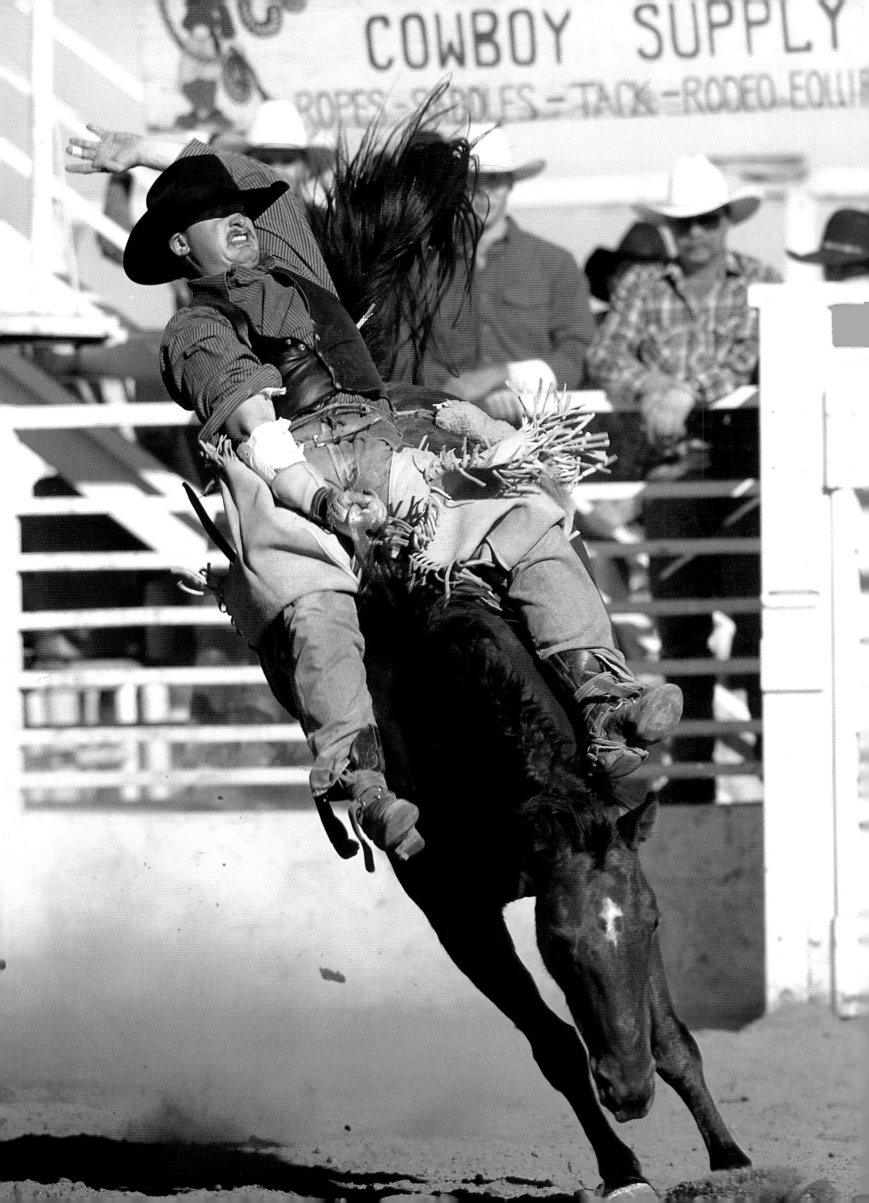

Made famous by movies of cowboys and Indians, the Palomino is a well-known horse. Although not a recognised breed in its own right, the Palomino has distinctive characteristics, among them the golden coat colour and white mane and tail.

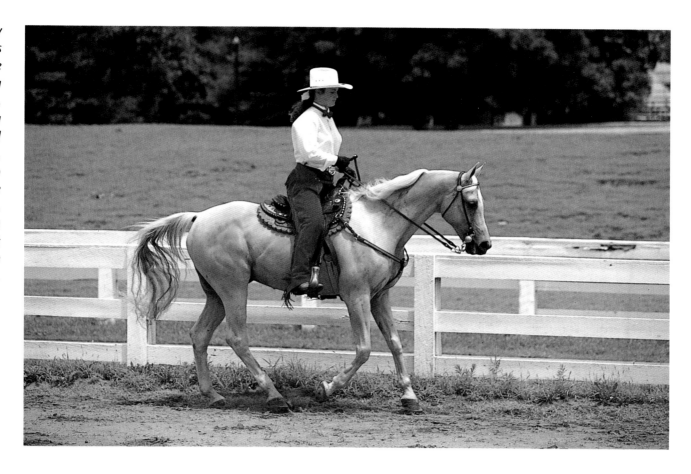

In an alternative to rodeo known in Australia as camp-drafting, a rider and mount drive a steer along a designated path to a predetermined end point. Skilled horsemanship is needed to complete the task successfully.

Rodeo is a spectacle unique to the United States. In the category shown here—saddle bronco riding—the rider has to stay in the saddle of his unbroken horse for at least ten seconds.

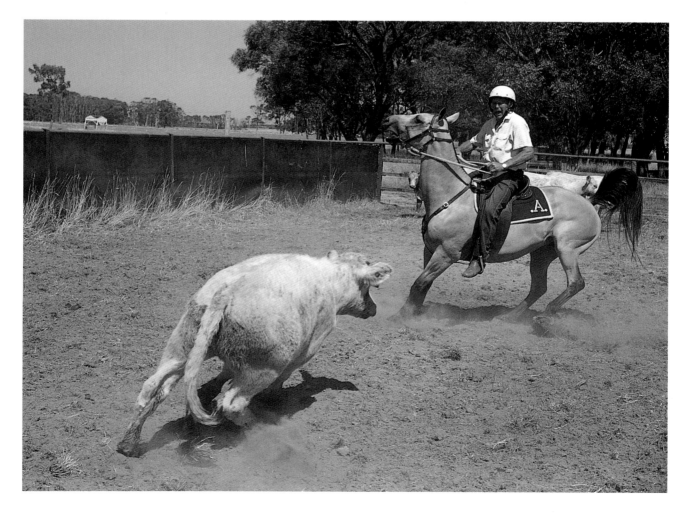

established a stud at Lipizza. The original stock came from Spain and had Arab, Andalusian, and Barb ancestors. Danish, Italian, German, and finally Arab stock were used to refine the breed, which is no longer altered in any way. Lipizzaners can be trained well and are obedient; they also have good stamina. They stand 15.1 hands high but are best known for their beautiful, pale-grey coats.

The development of horse breeds for riding and pleasure is not, of course, confined to Britain and America alone. Almost all European and Asiatic countries have been active in the field and the process continues to a lesser extent in South America and Australia to this day. The influence of Arab and Thoroughbred blood is strong in the ancestry of many of these breeds.

Mention must be made of the history and legacy of horse breeding in mainland Europe. Many of these breeds, although used nowadays mainly for pleasure riding, originated as working animals, their specific tendencies enhanced through careful breeding.

Germany and its neighbour Austria have produced a range of well-respected breeds over the last several centuries, each named after its region of origin. For example, the Holstein, first known more than four

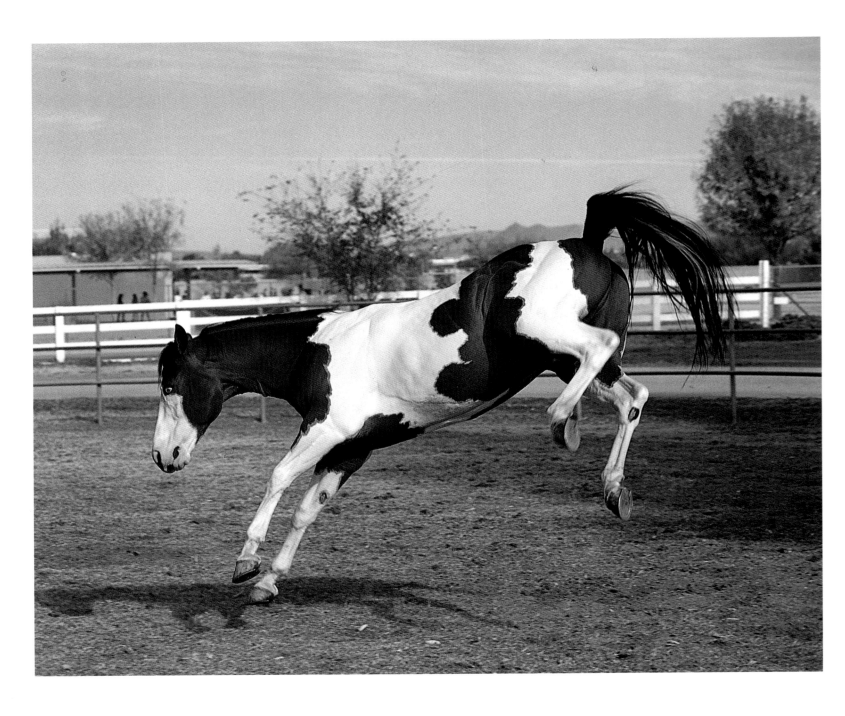

centuries ago, comes from the low-lying area of Schleswig-Holstein in Germany. Today it is as equally popular abroad as it is in its native land and is renowned as a good show-jumper. It was developed from the local Marsh Horse, interbred with, among others, Andalusian and Thoroughbred lines.

Although today considered a German breed, the Trakehner has had a chequered history. Established in 1732 in Trekehnan, then in East Prussia, it was a popular eighteenth-century breed, with Oriental stock and Thoroughbred blood in its ancestry.

After World War II, the Trakehner was bred in western Germany, where it has acquired a reputation as an excellent jumping horse.

Europe's Great War Horse is thought to be the main ancestor of the Hanoverian, one of Germany's most popular warmblood breeds. Arab, Thoroughbred, and Trakehner blood were used to refine and develop the breed and now it is popular both as a pleasure horse and as the mount of serious equestrians. The Westphalian is a similar breed, in both appearance and heritage. Both stand 16.2 hands high. The Westphalian bloodline

The Noriker is a heavy, coldblood breed from southern Germany and Austria. Its hardiness, powerful build, and even-tempered nature made it ideal for arduous work in the mountains.

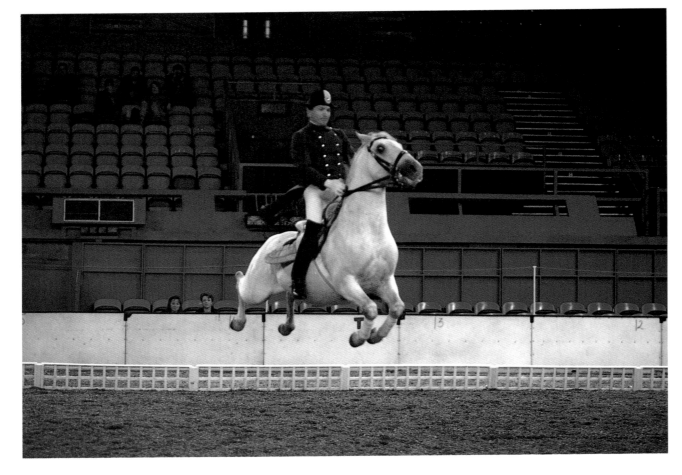

A much-loved Lipizzaner performs at the Spanish Riding School in Vienna, Austria. The breed has a powerful and athletic build; its intelligence means that it responds well to intensive training.

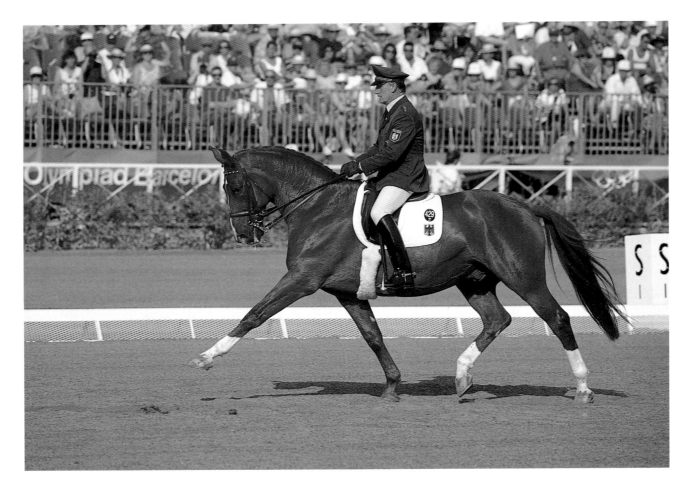

Months, if not years, of training are needed before a rider and horse can undertake a dressage competition in the ring. For best results, the rider must be in complete harmony of movement with his or her mount, in this case a Westphalian.

traces back to Hanoverian stock, improved with infusions of Arab and Thoroughbred strains.

Highly popular as a riding and driving horse, the Oldenburg is large, standing 16.3 hands high. Originally from East Friesland, a part of Holland, its complex ancestry includes Andalusian and Barb forebears, as well as infusions of Hanoverian and Thoroughbred lines.

In France, as in many other European countries, horse breeding has always been taken very seriously and is regulated by a department of the government. Perhaps the most important breed used for pleasure riding is the Selle Francais. Powerfully built, it stands 16 hands high and has stamina and a pleasant nature, an ideal combination for competitive sport.

In Holland, warmblood breeds include the Gelderland and the Groningen, which are comparatively small horses, standing 15.1 and 15.3 hands high respectively. They are exemplary horses for student riders and can also be driven. The modern-day Friesian is another Dutch warmblood, smaller still than its cousins, standing 15 hands high. It is descended from old Friesland Stock horses, with infusions of Oldenburg, Andalusian, and Oriental blood.

The elegant proportions of this Trakehner stallion reveal the Thoroughbred blood in its ancestry. At one time, in its native East Prussia, it was considered among the finest of riding horses.

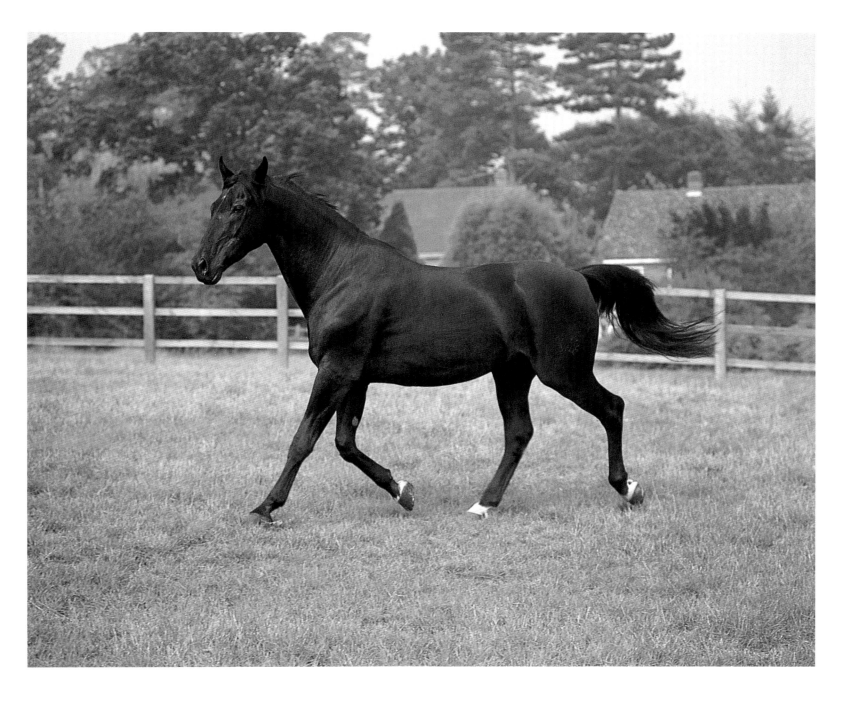

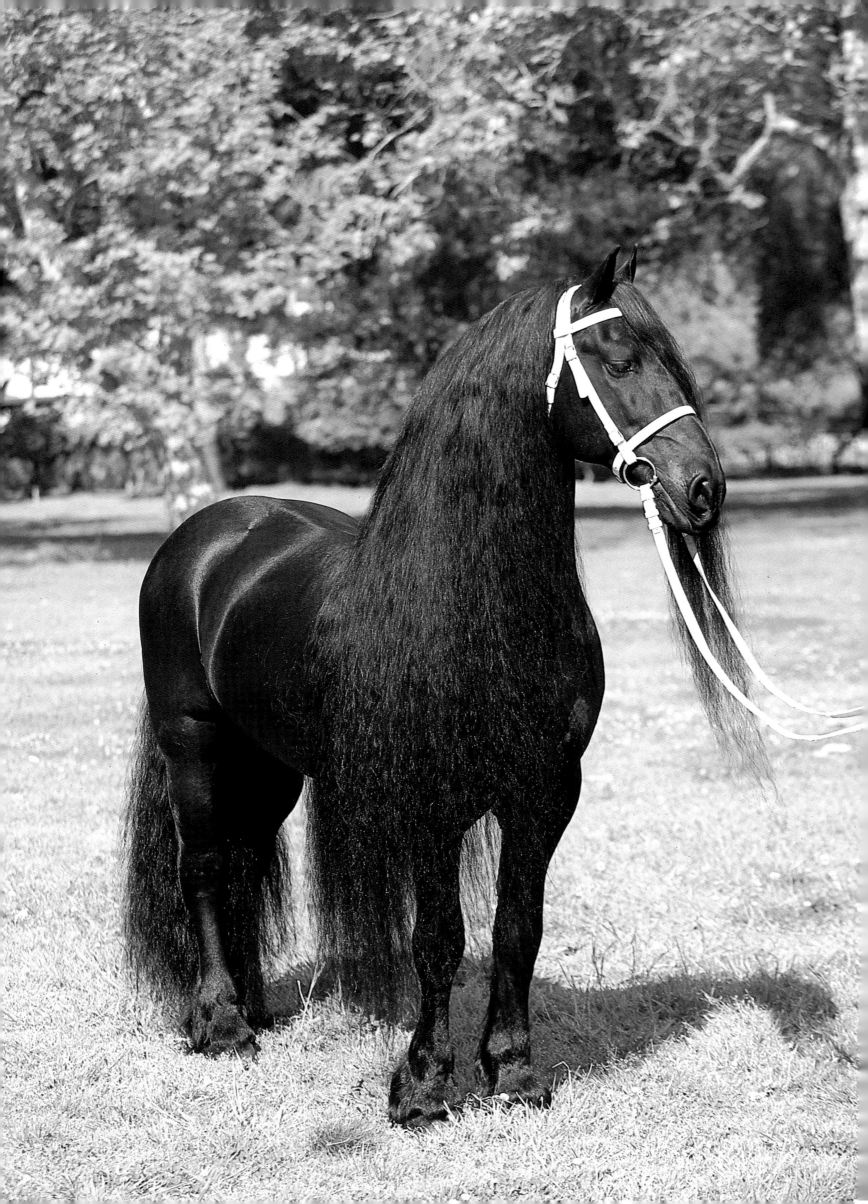

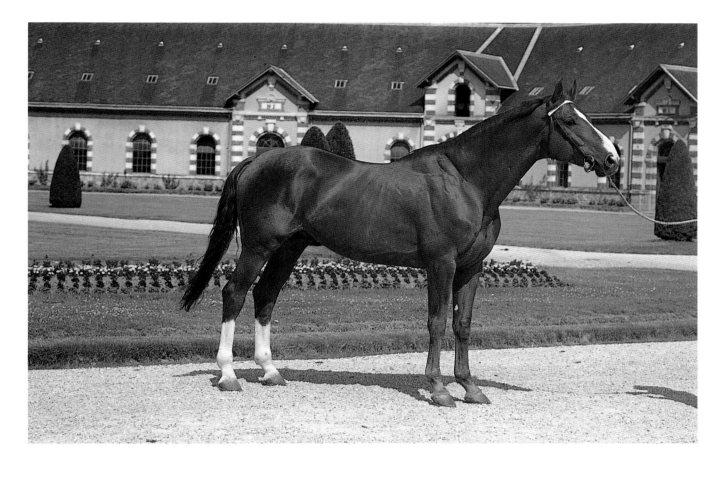

Originating in northern France, the Selle Français is an even-tempered horse, popular in competition. It stands 16 hands high and has very powerful hindquarters and a strong back.

Although not recognised as a true breed but classified as a type, this magnificent Normandy Cob displays a noble lineage with its strong neck, long back, and powerful legs.

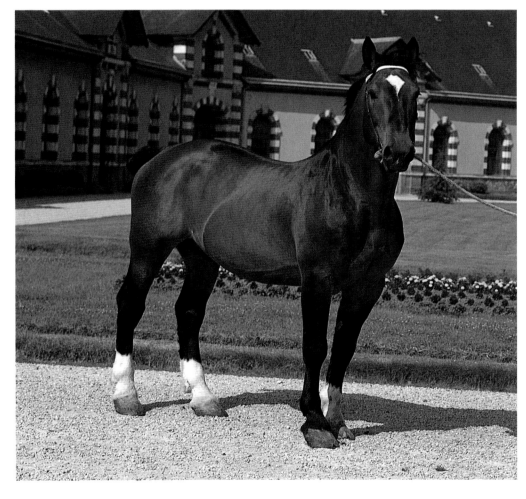

The Friesian is an ancient breed that originally came from the Dutch islands of the same name. As this picture demonstrates, it has a full mane and feathering on the feet.

Following page: Racing attracts a huge following at tracks all around the world. Here, at Cheltenham, many famous and lucrative races are run. The winners, both jockeys and horses, become household names.

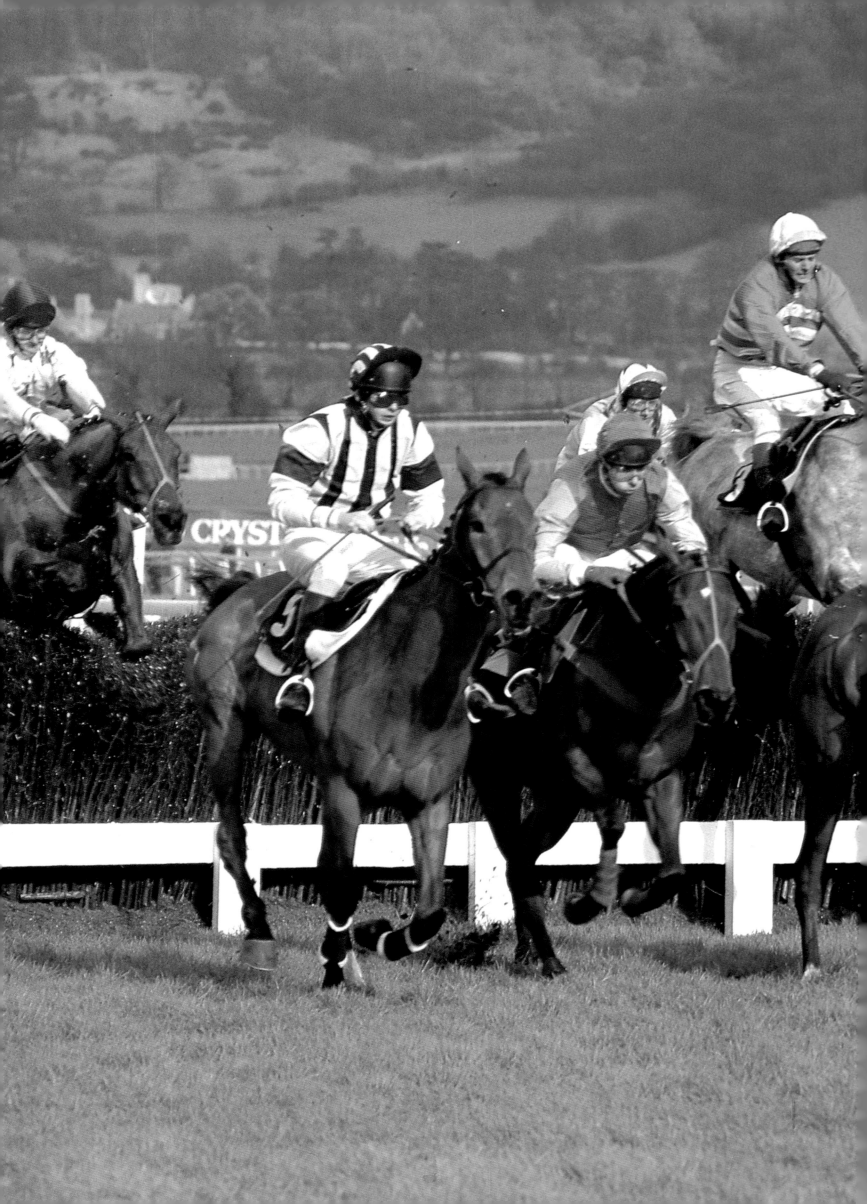

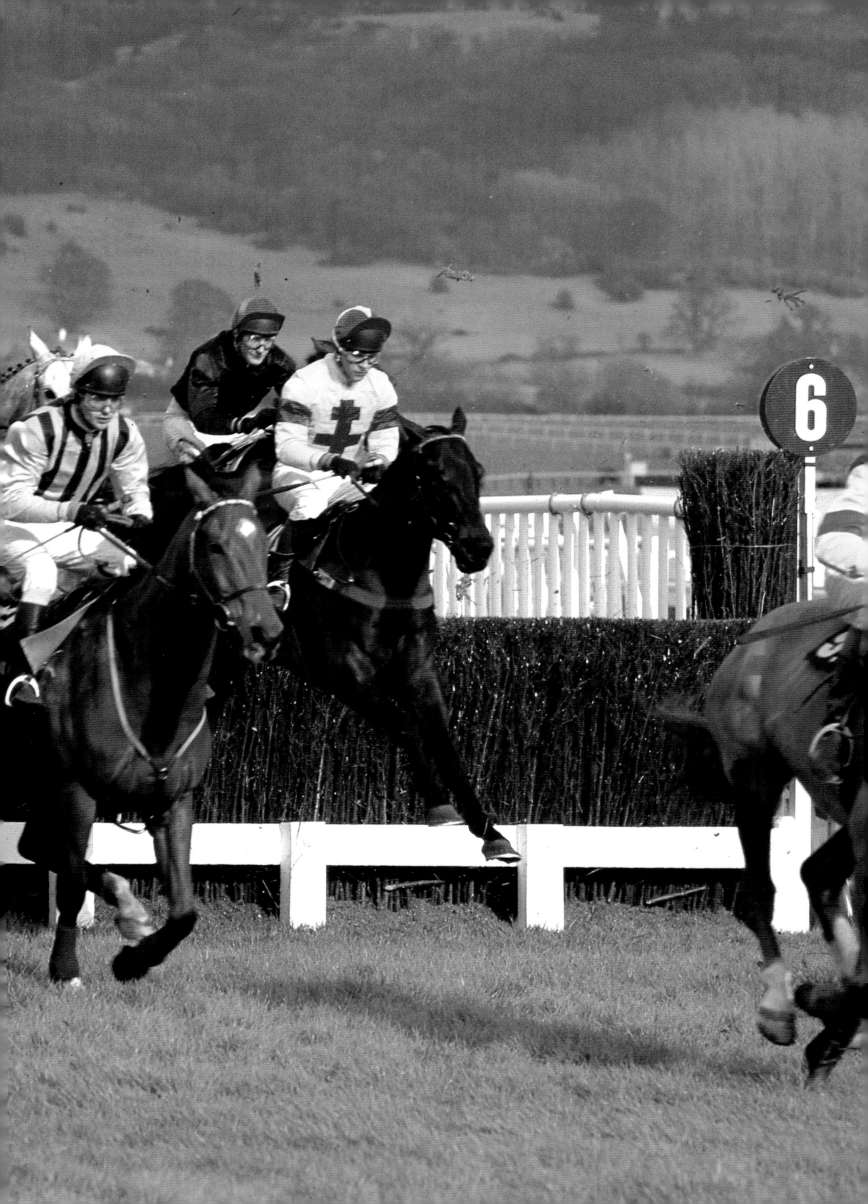

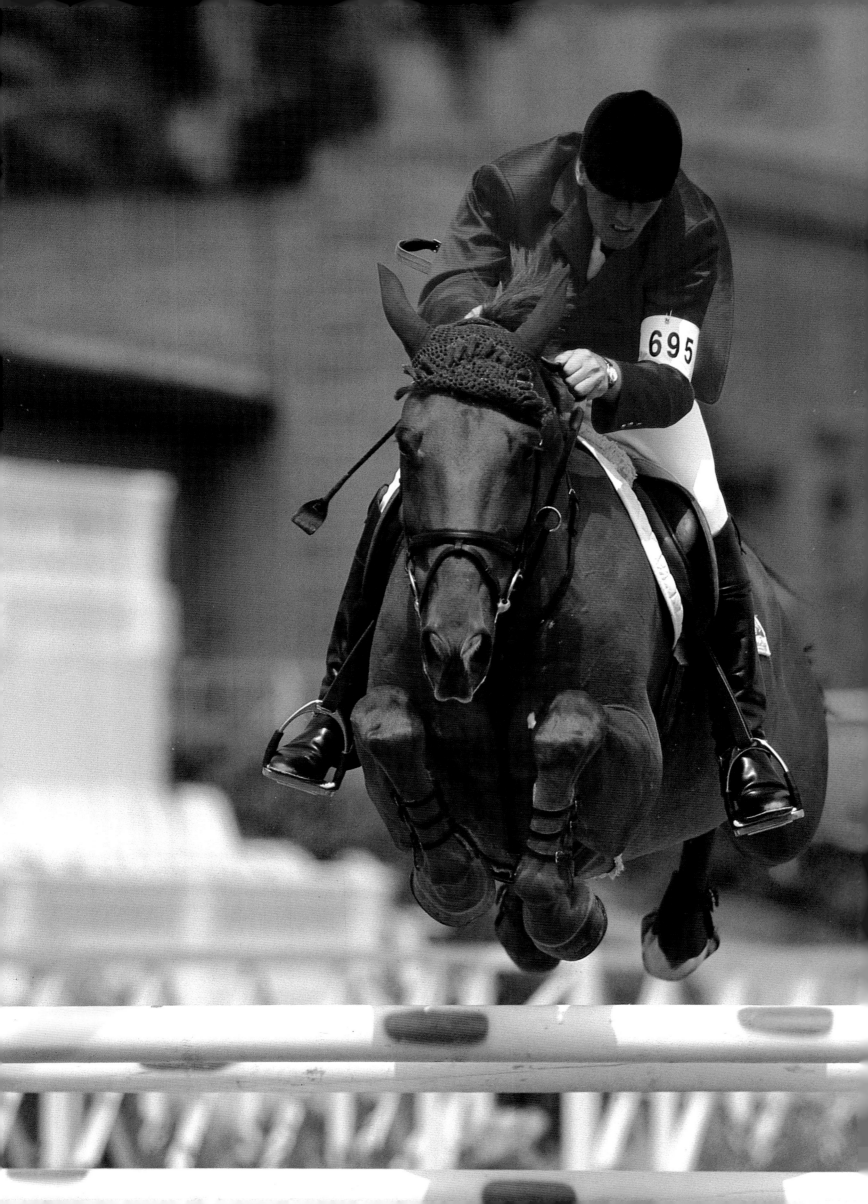

Officers at the Cadre Noir, the French Cavalry School, engage in a race. The school trains both horses and riders to the highest levels of endurance and skill.

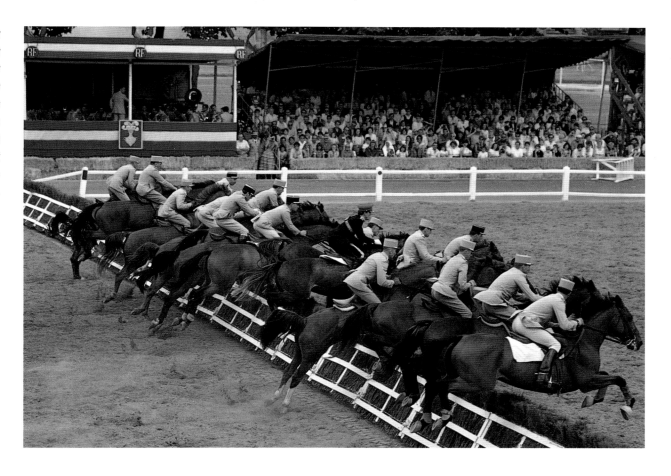

Racing occurs either on the flat, or involves jumping over birch fences; this is referred to as steeplechasing. The jumps, such as this one at Cheltenham, are potentially dangerous and falls can result in injury to both horses and riders.

A rider and horse, here a Belgian warmblood at the 1992 Barcelona Olympic Games, concentrate on completing a jump course. To reach this level of competition, both participants must trust each other and have a considerable degree of empathy.

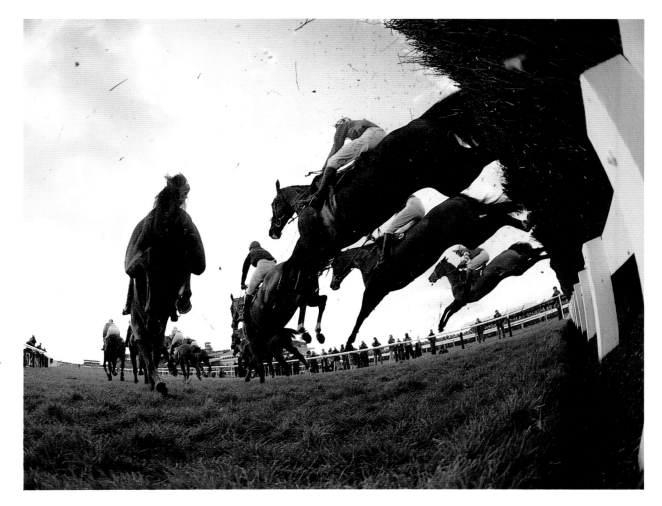

Of Russian descent, the Orlov, named after Count Orlov, is widely considered to be the best trotting breed in the world. Unlike some breeds of horse, it responds well under harness, as in this troika being driven at the Moscow Hippodrome.

The Iberian peninsula has a long history of horse breeding. The sphere of influence of Iberian breeds extends to North and South America, since Spanish conquistadors and colonists reestablished horses in the New World. Most famous of the Spanish breeds is the Andalusian, which originated in the southern Spanish region of Andalusia, hence the name. An excellent riding horse, the Andalusian is thought to be the ancestor of the Alter Real breed of neighbouring Portugal, refined and developed with the incorporation of Arab, Thoroughbred, and Hanoverian bloodlines.

The history of man's advancement over the last five millennia is inextricably linked to his association with the horse. By single-minded selective breeding, a varied range of breeds were created to facilitate the needs of transport, agriculture, and industry. Today, although man's technical ingenuity has rendered the horse redundant in many of these roles, its importance in leisure and sport has never been greater. Given the existing ties between us and the horse, our bond is likely to remain strong for several millennia to come.

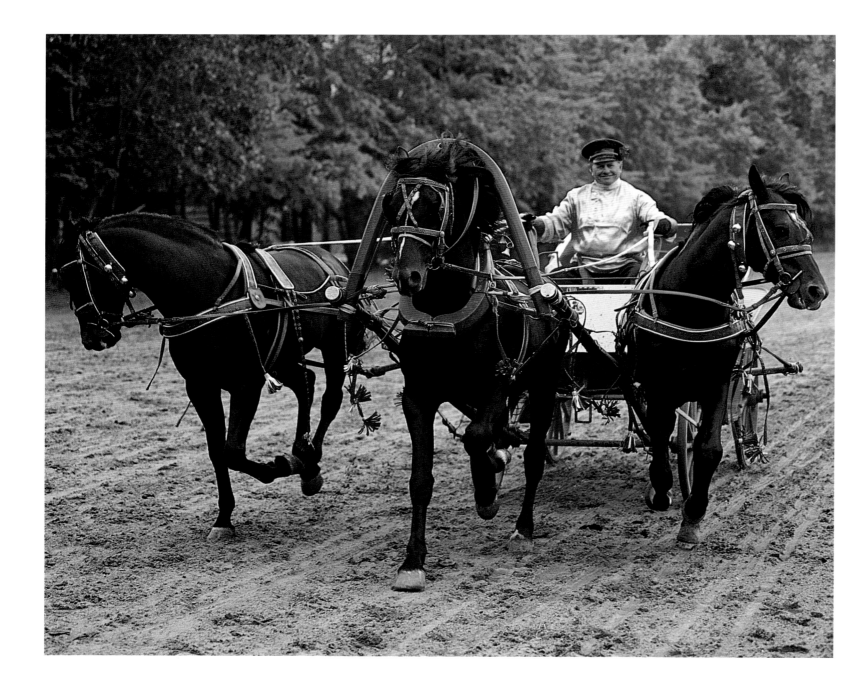

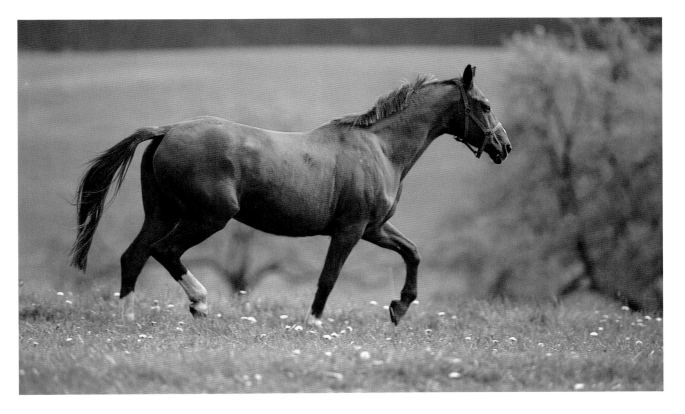

Its build and grace mean that the Westphalian is a breed ideally suited to general and competitive riding. It stands 16.1 hands high and originally came from Westphalia in Germany.

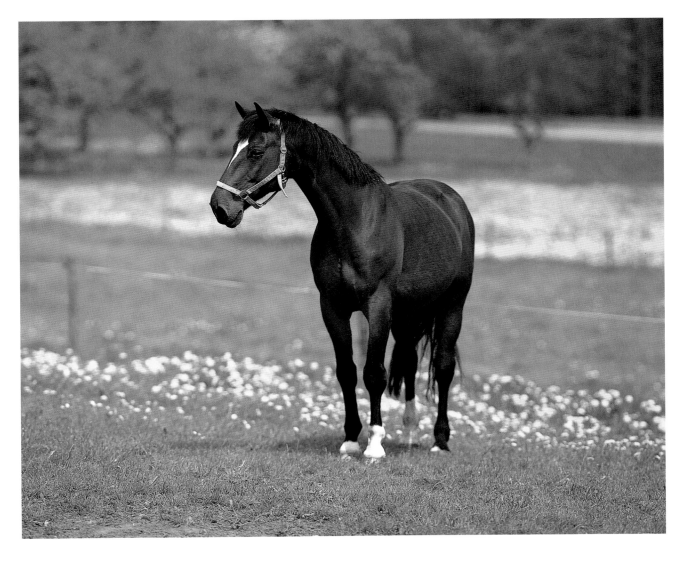

As its name suggests, the French Trotter is ideally suited to the sport of trotting, although this is by no means the only use to which it is put. It is a vigorous horse standing 16.1 hands high.

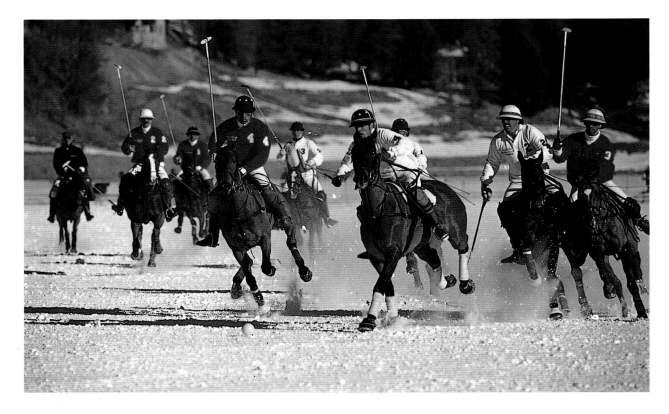

The ancient sport of polo takes place in a winter version at St. Moritz on a snow-covered field. Polo ponies must be obedient and sure-footed at the best of times; under these conditions they must be especially so.

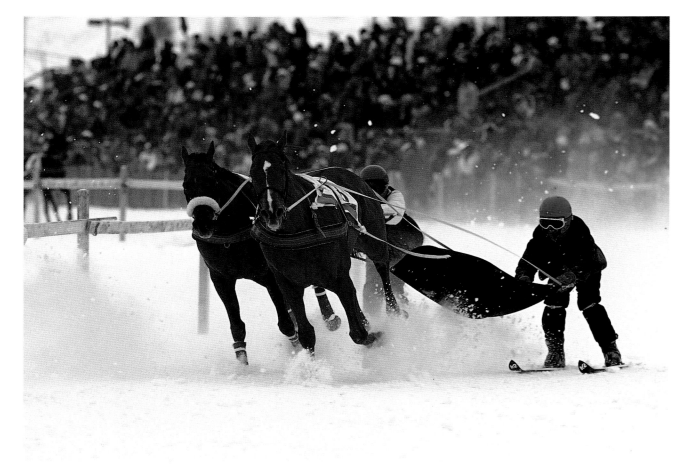

Competitions involving horses are not always confined to grassy turf. Here at St. Moritz the horses are pulling skiers, running on a surface of compacted snow.

The Hanoverian is probably Germany's best-known and best-loved breed. Much favoured as a riding horse, the Hanoverian is descended from the Great War Horse but has had infusions of Arab and Thoroughbred into its bloodline over the centuries.

INDEX

*Page numbers in **bold-face** type indicate photo captions.*